Project: Collage

to Archie... with love xx

First published in Great Britain in 2019
by ILEX, an imprint of
Octopus Publishing Group Ltd
Carmelite House
50 Victoria Embankment
London EC4Y 0DZ
www.octopusbooks.co.uk
www.octopusbooksusa.com

An Hachette UK Company
www.hachette.co.uk

This edition 2024

Text and illustrations copyright © Bev Speight 2019
Design and layout copyright © Octopus Publishing Group 2019

Distributed in the US by
Hachette Book Group
1290 Avenue of the Americas
4th & 5th Floors
New York, NY 10104

Distributed in Canada by
Canadian Manda Group
664 Annette Street
Toronto, Ontario
Canada M6S 2C8

All rights reserved. No part of this work may be reproduced or utilised in any form or by any means, electronic or mechanical, including photocopying, recording or by any information storage and retrieval system, without the prior written permission of the publisher.

Bev Speight asserts the moral right to be identified as the author of this work.

ISBN 978-1-78157-953-4

Printed and bound in China

10 9 8 7 6 5 4 3 2 1

Publisher: Alison Starling
Editorial Director: Helen Rochester
Commissioning Editor: Zara Anvari
Managing Editor: Rachel Silverlight
Art Director: Ben Gardiner
Designer: Bev Speight
Assistant Editor: Stephanie Hetherington
Production Manager: Lisa Pinnell

Project:
Collage

50 projects to spark your creativity

Bev Speight

ilex

Contents

Collage 06

Freehand 10
01. Torn 12
02. Layers and tears 14

Colour 16
03. Perspective 18
04. Colour blocks 20

Build 22
05. Kaleidoscopic 24
06. Shape 26
07. Grid 28

Spaces 30
08. Creating space 32
09. Punching holes 33
10. Confetti collage 34

Texty 36
11. Type as texture 38
12. Multilingual 40
13. Features 42

Menagerie 44
14. Mirror mirror 46
15. Anthropomorphic 48
16. Sketch 50

3D 52
17. Assemblage 54
18. Trompe l'oeil 56
19. Juxtapose 58
20. Earthy textures 60

Canvas 62
21. Recycle 64
22. Suits 66

Washi 68
23. Washi pattern 70
24. Washi layers 72

Surreal 74
25. Thirds 76
26. Transformation 77
27. Split and repeat 78
28. Humour 80
29. Upside down 81

Distort	**82**
30. Tessellate	84
31. Spin	86
32. Stretch	88
Pattern	**90**
33. Aura	92
34. Pyramids	94
35. Scene within a scene	96
Persona	**98**
36. Human combo	100
37. Mash-up	102
38. Graphic	104
39. Stitched	106
Joiners	**108**
40. Building a picture	110
41. Deconstruct	113
Mixology	**114**
42. Oil pastel	116
43. Tissue paper	118
44. Paint	120
45. Disintegrate	122

Repeat	**124**
46. Movement	126
47. Multiply	128
Fashion	**130**
48. Frame it	132
Inside out	**136**
49. Reveal	138
50. Peepholes	140
Acknowledgements	142
About the author	143

Collage

Welcome to the world of contemporary collage. Collage invites you to collect, combine and transform existing imagery and ephemera, both old and new, into entirely original compositions. Tactile, versatile and accessible, collage encapsulates the magic of reinvention. Collage can elevate trash into treasure. It is an art form for everyone and for every budget.

Derived from the French terms *papier collé* (pasted paper) and *découpage* (from *découper*, to cut out), collage describes the process of applying cut papers to different surfaces. It was not always considered 'high art', but twentieth-century artist visionaries would change that. They understood how the simplest of processes and mediums could become a powerful tool for self-expression, for pushing artistic boundaries and even delivering social and political commentaries.

Collage promises endless possibilities and is the perfect platform to trial the favourite techniques, methods and subjects that inspired and captivated some of the twentieth century's greatest artists. When, in 1912, Pablo Picasso and Georges Braque began introducing real newspapers and wallpaper clippings into their cubist works, they were not only giving the art world a new medium to play with, but introducing a new form; one that was defined largely by humour and playfulness, challenging the boundaries between art and reality.

Through collage, you'll learn how to manipulate, combine, deconstruct and reconstruct images. As you dive deeper you'll discover how the art of collage stretches the imagination and encourages a reinterpretation of the familiar and mundane. Try your hand at photomontage, a technique championed by Dada artist Hannah Höch, and see how you can make an everyday scene entirely surreal (page 74). Reinvent space using David Hockney's famous joiner technique (page 110) or create by destroying, like Mimmo Rotella (see overleaf) through the spontaneous and deeply satisfying art of *décollage*.

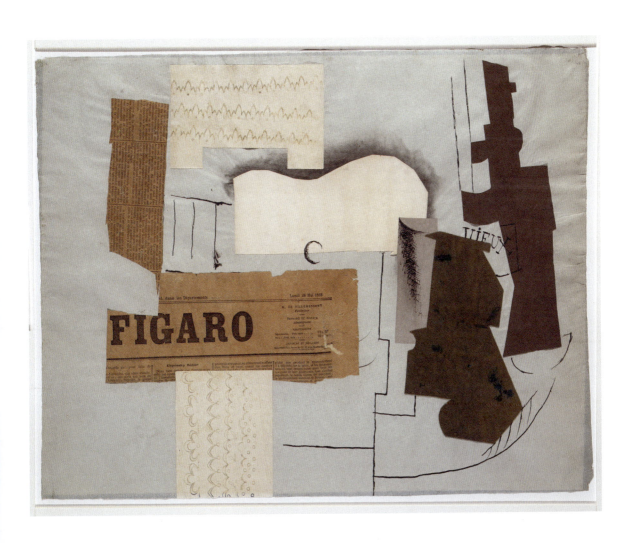

Bottle of Vieux Marc, Glass, Guitar and Newspaper
by Pablo Picasso, 1913
(Printed papers and ink on paper) Tate

Collage 7

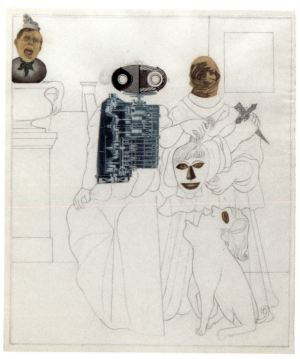

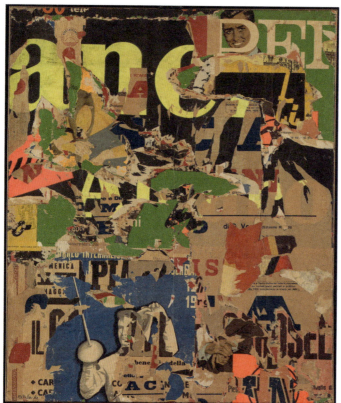

Above: *Keep your Head* by **Edward Burra, 1930** (printed papers and graphite on paper) Tate

Left: *Con un sorriso (With a Smile)* by **Mimmo Rotella, 1962** (printed papers on canvas) Tate

8 Collage

The 50 contemporary collage projects within this book will both inform and inspire you to experiment with a range of materials, techniques and themes. Each chapter centres around a different subject, and the projects within develop on this theme and offer a variety of fresh approaches to it. Simple step-by-step directions demonstrate the creative process behind an example artwork. With a great mix of collage styles to choose from, you can start at the beginning and work your way through the book, or dip in and out of the projects as you wish.

As you grow in confidence, you'll find your understanding of composition, media, shape and colour develops. You might discover a new interest in typography by incorporating text into your work (page 36). Perhaps you'll leap from two-dimensional artworks to three-dimensional assemblages (page 52), or find yourself discovering a new media by using it in your collage. You might enjoy the linear process of using washi tape (page 68), or the spontaneity of a line drawing inspired by your collage elements (page 50), a little like Edward Burra, whose clear lines contrast with surreal, photographic collage elements.

No specialist items are required for any of the featured projects. You'll need only everyday materials and tools that you can easily get your hands on: family photographs, vintage and contemporary magazines, worn out books from charity shops and thrift stores, everyday ephemera and objects such as tickets, packaging and labels. Even a modest collection of materials will make for an almost infinite source of visuals that you can recycle. Gathering is an essential part of collage and you should constantly be on the look-out for useful images. Start hoarding today to build your own collection and keep adding to this so that you'll have your own impressive archive of imagery, ready for whenever inspiration strikes. Often it will be the story of these pieces which forms the seed of an idea, so look to your materials and use them to decide where you want to start. Once you have something in mind, use this book to help you come up with the design and find the best process or technique to realise it.

It's time to discover your own collage style. Be inspired by what you see, learn by doing and feel encouraged to explore further. Cut, rip and paste your way to unique works of art that you can call your own. *Project: Collage* is packed with ideas to get you started. This is only the beginning.

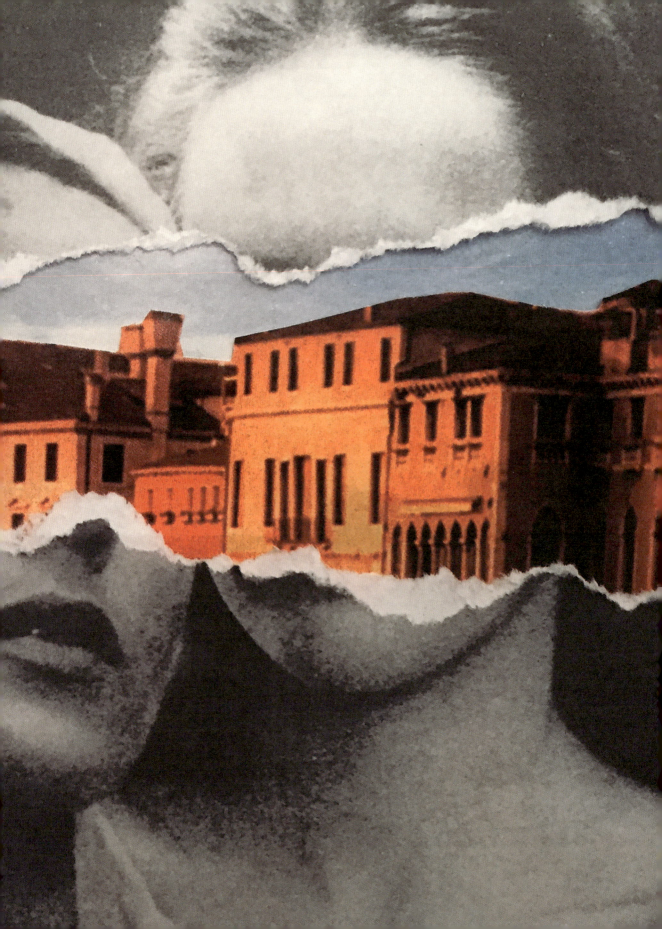

Freehand

Random rips and tears through layers of imagery, otherwise known as *décollage*, offers a satisfying uniqueness to each collage composition as you can never knowingly repeat a tear. Soft, torn paper edges blend images together, but they can also be juxtaposed with blunt, straight cut edges. In this freehand approach to collage, contrasting images merge, with the undulating ripped paper edges casting slight shadows and adding depth. Consider your composition and embrace opportunities to frame, highlight or distort elements within. Paste and tear your way with the art of *décollage*, embracing the spontaneity of raw edges and the unexpected compositions that materialise by chance.

Play with tears to create dramatic contrasts between colour and black-and-white imagery, explore rugged seascapes with a single sharp focal point, and randomly rip back the layers to reveal powerful compositions.

```
Torn Apart
(magazines, glue)
```

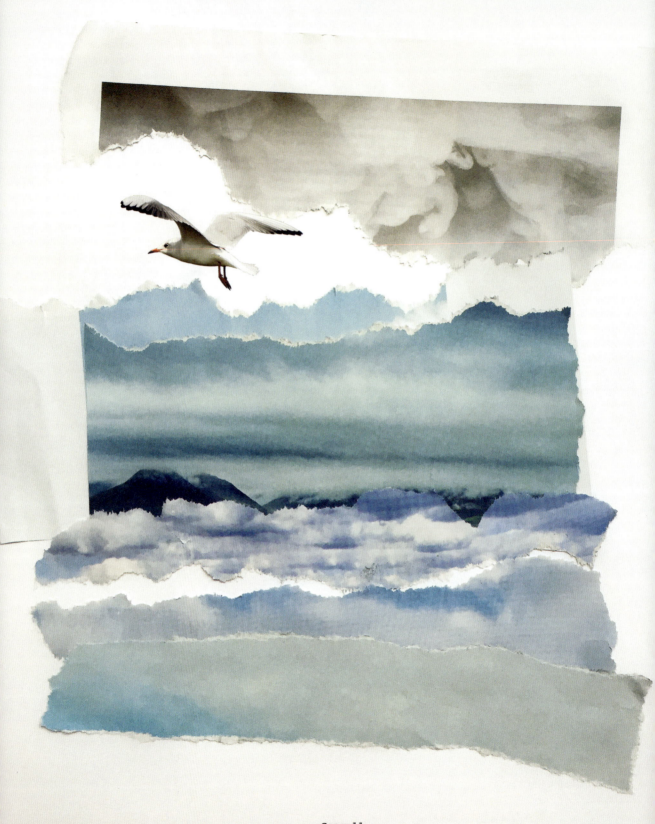

Seagull
(magazines, paper, scissors, glue)

01. Torn

Random tears create unique shapes that lend themselves perfectly to scenes of nature, such as rolling hills, stormy seascapes and wild mountain ranges. Seascapes make a good subject for this spontaneous type of collage as no two wave formations are ever the same, but this technique could work for many different kinds of landscape.

Look for contrasting imagery to use, and remember that just because you're making an image of, say, a seascape, the constituent parts don't have to come from images of seas. Here, for example, I've created my seascape out of different skies. Embrace the transformative element of collage. Placing a single sharp image on a roughly layered background gives the image focus and is a simple formula for creating an impactful collage.

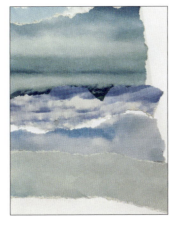

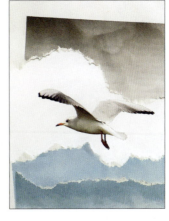

1.
Collect different images of one landscape element, such as skies; each with its own quality. Tear each sky image into strips of varying widths and shapes. Gently guide your tears to create a mix of rough, wavy and straight edges. Ripping with or against the grain will affect the edge.

2.
Using a white or textured paper as the background, build the seascape image by juxtaposing dark strips of sky with lighter ones. Overlap some strips, but leave gaps between others. Rearrange the strips until you are happy with the composition. Leave a space clear for adding a focal point.

3.
Choose a strong single image, such as a seabird in flight, and cut it out neatly. This is the focal point of your image. Position the cut-out image within the seascape and readjust the strips if necessary. Once you are entirely satisfied with the composition, glue the strips of paper and the cut-out in place.

02. Layers & tears

Inspired by ageing, peeling billboard posters, the technique of *décollage* can partially reveal secret histories hidden beneath vibrant layering. You can peel the layers back to unveil colours, textures, faces and shapes seemingly from the past. As you tear through each layer, the composition will continue to change, so capture each reveal with your camera. With this technique there is no going back!

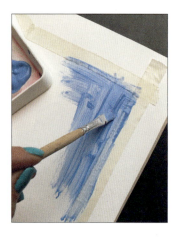

1.
Start by painting a base colour for your composition. Mask a rectangle with tape and then, with a large brush and mixed paint, start to block in the colour. Remove the tape to leave a neat edge.

2.
Collect your images. Using a glue stick or PVA glue and a brush, build up layers of pages torn from magazines, one on top of the other, in a random arrangement. Build up the layers to a good thickness, then leave to dry overnight.

3.
When dry, tear away the layers in random places to partially reveal images, text and colours, until you reach a strong final composition. Photograph the process as each temporary composition is torn away until you reach the one you are happy with.

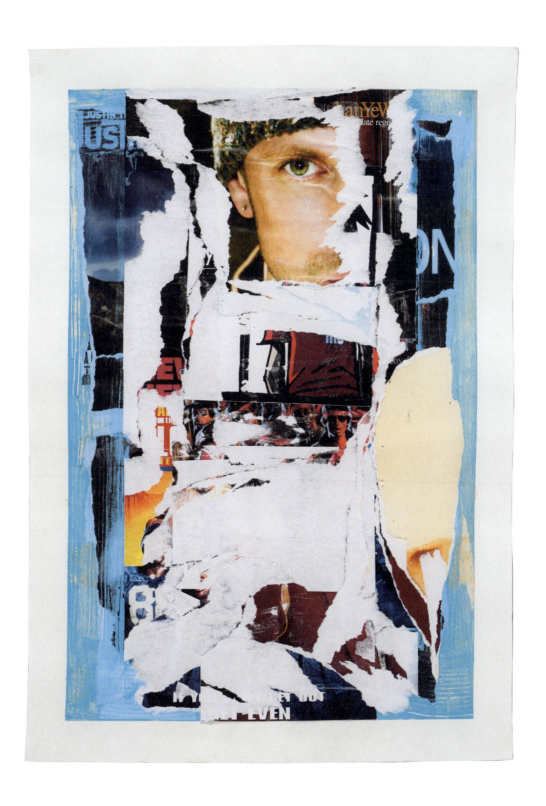

Connections **by Baha Khodadadi**
(magazines, paper, scissors, glue, paint, brush)

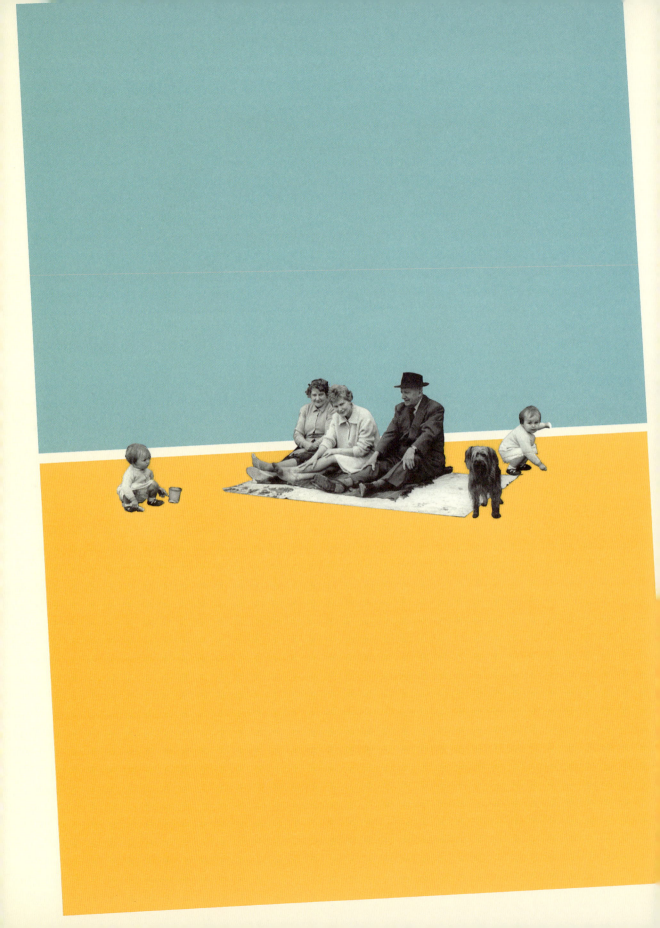

Colour

Experiment with planes of flat colour within collage. Reducing an element of an image down to a single shade – turning a sky into an expanse of pure blue, for example – simplifies the image and clarifies the story it is telling: the colour blue becomes a shorthand for sky. Take inspiration from vintage railway posters of the 1930s with their use of heightened colours in unexpected, sometimes clashing combinations, in which skies aren't necessarily blue and fields aren't always green.

When you use planes of flat colour, more detailed sections of a collage are thrown into sharper relief. Position clusters of detail to create focal points set against strong coloured backgrounds. Old family photographs work well for this type of collage – but make a copy so the original photograph remains intact. Remove any background detail and replace it with meaningful colour.

This technique can change the context of the original and tell a different story: isolate a lost cat with perspective; replace part of an image with an abstract composition; or create coloured shapes for an image to disappear into.

```
Whitby Beach
(photograph, coloured paper, scissors, glue)
```

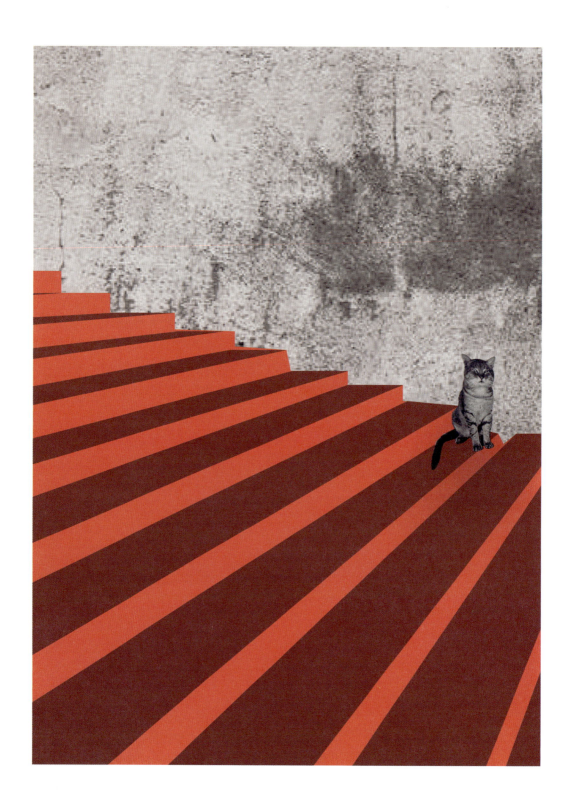

Waiting

18 Colour (photographs, coloured paper, scissors, glue)

03. Perspective

Architectural structures within an image can be replaced by flat colour to dramatise a composition and create the illusion of perspective. In this instance, the narrative of the collage remains the same as the original scene, however the resulting image is far more striking with the stone steps of the photograph being replaced by shades of red to form a geometric pattern. Retaining a neutral back wall and then adding the cut-out of the cat to act as a focal point makes the illusion of perspective more convincing and draws the eye further into the image.

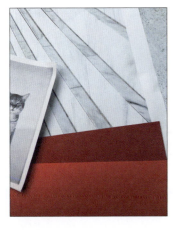

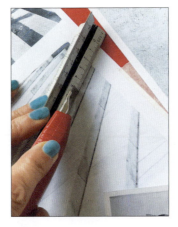

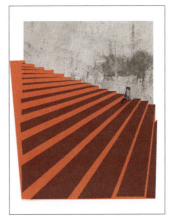

1.
Collect the materials for your collage. Choose a main image with perspective – steps, for example – then select coloured paper to replace it. Here, two shades of red will replace the treads and rises of the steps. Different shades of one colour can make a more convincing illusion than clashing colours, but experiment. The cat image will add a great focal point.

2.
Make two copies of the main image (you may need more if you're replacing more elements in your image). Place one copy over each sheet of coloured paper, and carefully cut out the parts to replace. Use different colours for different planes; for example, the tops of the steps here are in dark red while the vertical face is in the lighter shade.

3.
Replace the architectural element of the original image using the coloured strips. Cut out your chosen focal-point image (the cat, in this case) and position it within the scene to create a point of interest and enhance the perspective. Carefully crop the final image to remove extraneous edges.

Colour 19

04. Colour blocks

Even when replaced by flat colour, an object or element can remain legible. Here, Frank's chair is still apparent even though all the detail has been removed. For this project, start with a black-and-white photograph with a clear subject, then cut away all of the surrounding information. Use coloured paper cut to reflect any spatial shapes removed from the original (only look for the large shapes, keep it simple). Colour choice is important as this can suggest any objects and emotions present in the original – wallpaper, a chair, sun shining through a window, for example. Also consider how the different colours will work together.

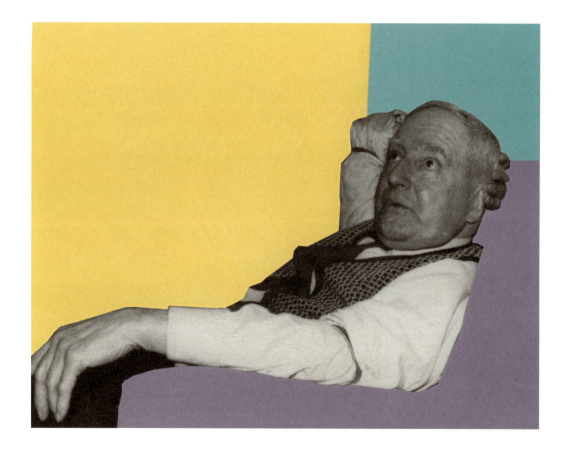

Frank
(photograph, coloured paper, scissors, glue)

Conversely, by using the same technique and replacing parts of an image with blocks of colour, an object can be removed from its original context, then recast and given an entirely new narrative – one that is abstract and playful, perhaps. Here, arms have been dislocated from their bodies and the coloured circles become an integral part of the reworked image. The strong shadows from the original photograph enhance the sense of depth within the collage and makes the idea of the coloured circles being three-dimensional holes more believable.

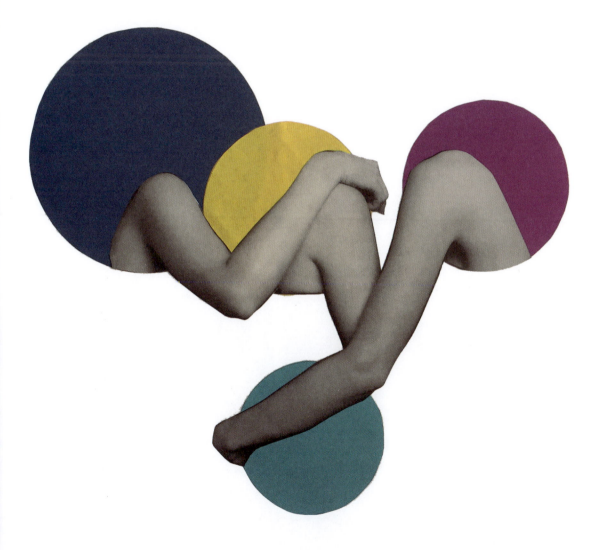

Arm in Arm
(photograph, coloured paper, scissors, glue)

Colour 21

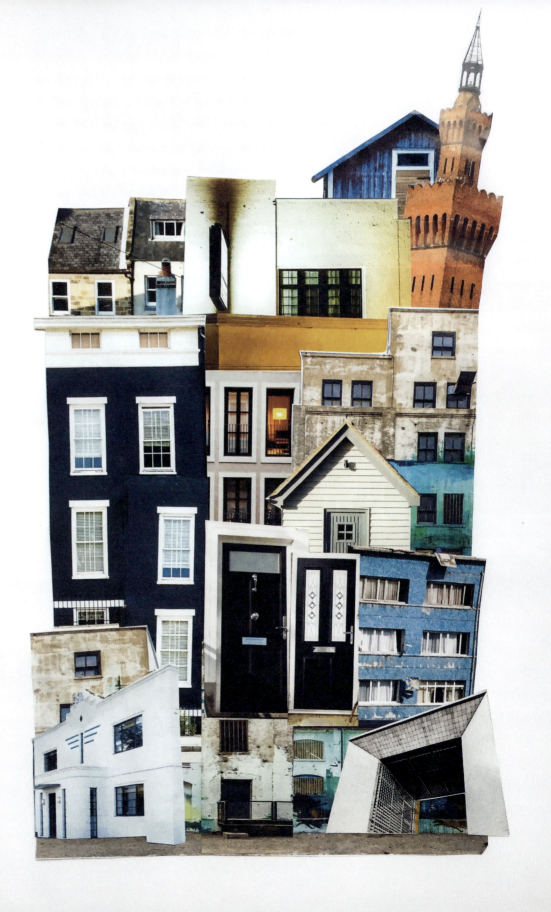

Build

Building on the themes of perspective and spatial awareness, now let's explore architecture. Designing and collaging a house or skyscraper from an array of varying architectural details is a useful exercise in shape and structure, but also allows you to experiment with distortion and abstraction while making a fantastical construction.

These projects will also challenge your imagination. You start with the familiar form of a building and then push the elements that comprise it to extremes. Gather not only the essential structural elements of a building, but also any unusual details that catch your eye – from slate roofs and peeling façades to twisted spires and impudent gargoyles. Do you want to create something uniform and minimal or ostentatious and random?

Be inspired by movements from history and construct a bold Brutalist structure made from the textures and shapes of interlocking imagery. Explore everyday surfaces and perspective lines to create entirely abstract compositions. Or conjure a kaleidoscopic world by duplicating and rotating images to create a repeat pattern.

Home
(magazines, paper, scissors, glue)

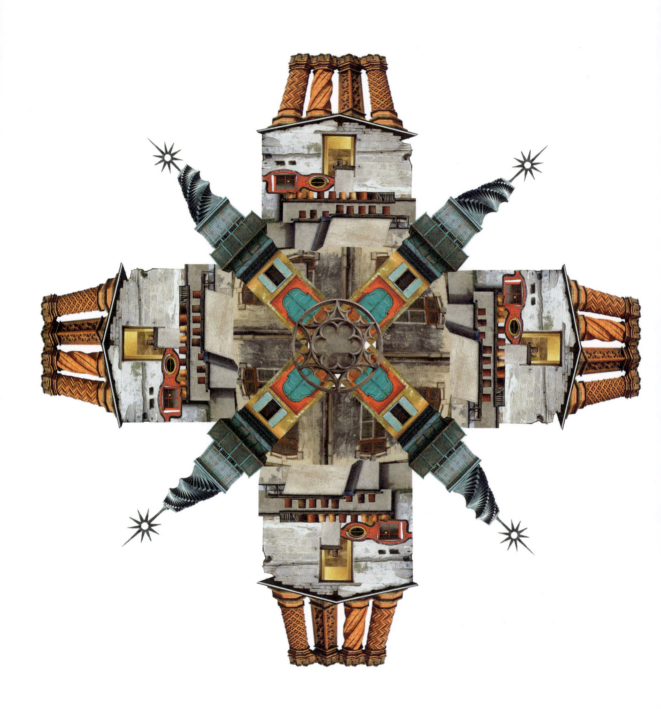

Twist

<u>24</u> Build (magazines, photocopier, white paper, scissors, glue)

05. Kaleidoscopic

Inspired by the symmetrical configurations inside a kaleidoscope, this project morphs two collaged structures together to form an intricate pattern. Use both complementary and contrasting architectural styles brimming with colour, texture and detail for striking results. Clone the elements of your building using a photocopier so that you can experiment freely.

Structure one

Structure two

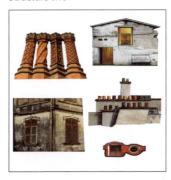

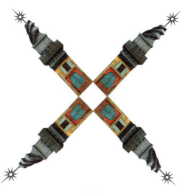

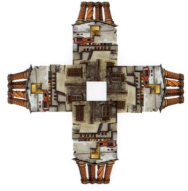

1.
Source a selection of architectural imagery from magazines and newspaper supplements. Isolate and cut out the key details of each building. Now decide which elements work together to create two unique collaged structures.

2.
Arrange the collaged structures separately, each on a white paper background. Glue the elements in position when you're happy with your compositions.

3.
Photocopy each collaged structure four times, then carefully cut them out again. Position the structures in a cross formation and then place one cross on top of the other. Add a central architectural detail (see opposite), if preferred, and then glue in position.

Build 25

06. Shape

This creation may no longer resemble a building, but the dramatic shape is a Brutalist structure on its own. Be inspired by a movement and create a Brutalist collage with crisp outlines that carve into a white background. Research the raw concrete block formations of the Brutalist movement of the 1950s and 1960s. Collect images of exposed concrete textures, geometric flourishes and repeat formations, then cut out and arrange to create an abstract structure. Why stop with Brutalism? These graphic shapes could easily translate into different styles of architecture such as Art Deco, Gothic and so on. Explore.

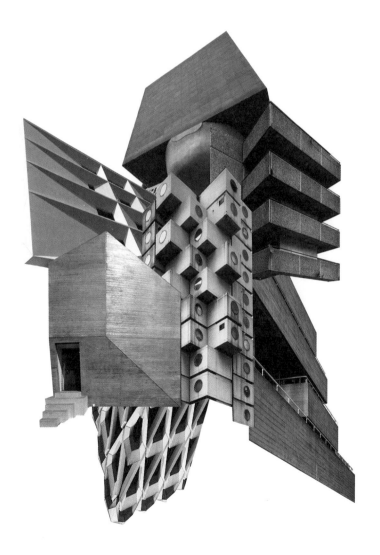

Brutal
(magazines, photocopier scissors, glue)

Expand your collages beyond an individual structure and create a whole space, reminiscent of an architect's concept artwork. Play freely with shapes and colours to create an outdoor space with ambience. Explore textures and surfaces. Mix realistic elements with flat colours and illustrations. Construct pathways for figures to populate. Create a familiar habitat from natural everyday materials, but with an abstract composition. The textures, patterns, areas of detail and flat sections together create an impression of a place.

Market **by Elizabeth Fadairo**
(magazines, photocopier, scissors, glue)

07. Grid

A grid of regular lines is a device that can unite seemingly disparate imagery into a cohesive collage. Draw a grid or multiple grids, then add individual elements on and within the lines. Different shapes of grid suggest different ways of using them. A triangular grid, for instance, invites you to explore perspective and can suggest a three-dimensional quality. Use a mix of elements, such as flat colours with stonework, human figures and flowers. Experiment until you feel like the composition is working. This style is reminiscent of Victorian flying-machine sketches, which inspired this piece, but look also to the inventive work of Leonardo da Vinci, whose sketches often started with a grid.

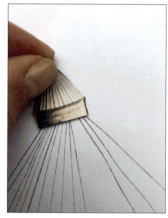
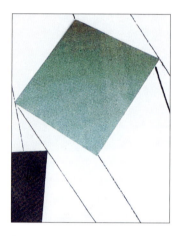

1.
Draw grid lines, freehand, using a fine black pen on white paper. Create perspective by starting at one point and fanning the lines outwards. Repeat from another one or two starting points, making sure the lines briefly cross in the centre of the paper.

2.
Look for elements to use on your grid. Architectural details such as floors or roof tiles will add dimension. Ornamental details, such as finials, will cover the points where lines converge. Abstract colours add further interest, while recognisable elements such as figures and flowers complete the fantasy.

3.
Cut out and position your pieces within the grid lines, aligning the angles to give an illusion of three dimensions. Try leaving space between the different collaged elements, allowing the grid lines to show. When you are happy with the composition, glue the individual elements in position.

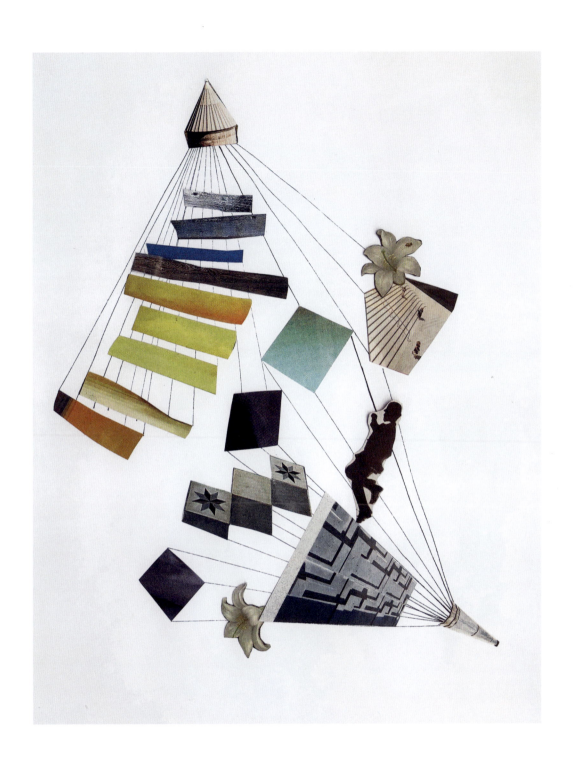

Steampunk
(magazines, pen, scissors, glue)

Build 29

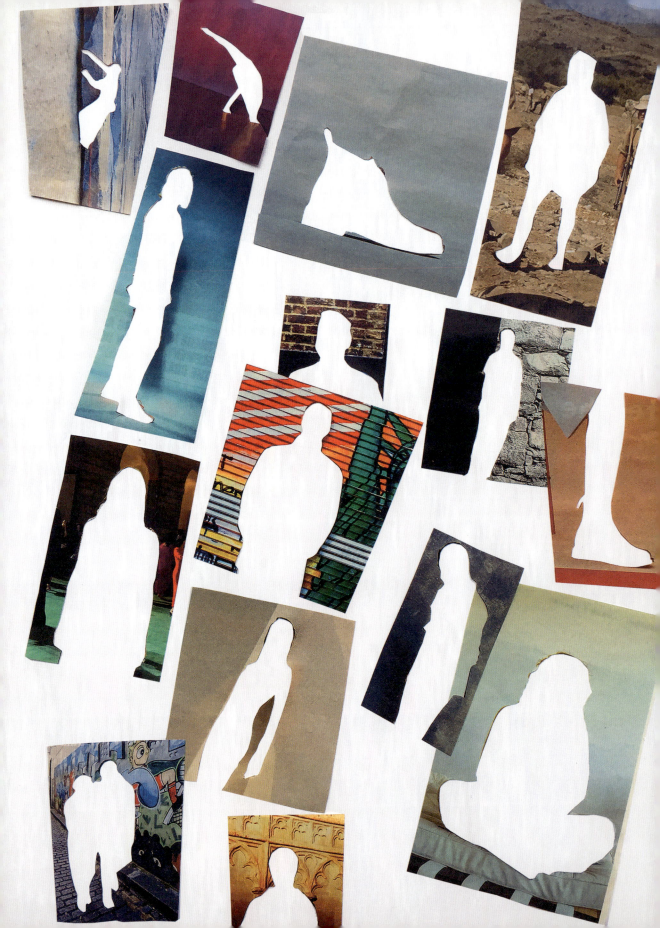

Spaces

Make a collage dominated by empty space. Negative space, as these empty areas are known, is usually found surrounding a subject in an image. We're going to reverse this. Cutting recognisable objects or abstract shapes out of an image transforms its focus or meaning into something new.

Create a selection of 'missing persons' by removing figures or objects from their backgrounds. Choose a variety of interesting poses and shapes, and consider carefully the background, which is now going to have as big an impact as the missing detail once did. Experiment with other ways of working with negative space; use a hole punch to eat away at your image in perfect circles, for example, or superimpose a new shape on an existing image, then cut it out.

Fill in the blanks – or don't! Find out how evocative a blank space can be.

```
Missing People
(magazines, scissors, glue)
```

08. Creating space

Negative space can add drama to an image. Experiment by obscuring an image with a blank paper cut-out in a shape of your choice. Here, for example, a face peeps out between fingers. Find an image of hands to use as a template – cut them out and draw around them on white paper, then cut that out. (You can reuse the original hands in another collage.) The cut-out hands have been placed over the face image and glued in place, blending with the white border and almost disappearing, to leave an intriguing composition.

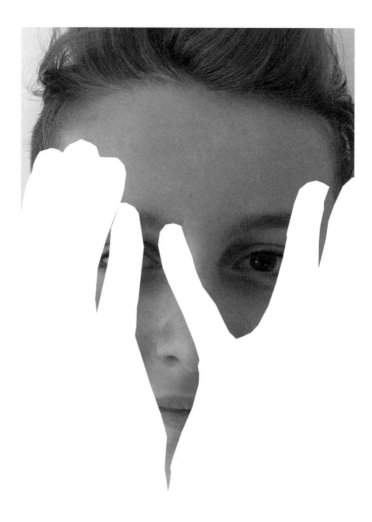

Hide
(photograph, white paper, scissors, glue)

09. Punching holes

Choose a dramatic image and then gradually eat away at the visual by punching a series of holes. Consider the placement of each hole as there is no going back once you have cut it out. The eye will be drawn to the greatest concentration of holes, so think about how you distribute them. Place the image over a white or coloured background – whichever works best to highlight the spaces.

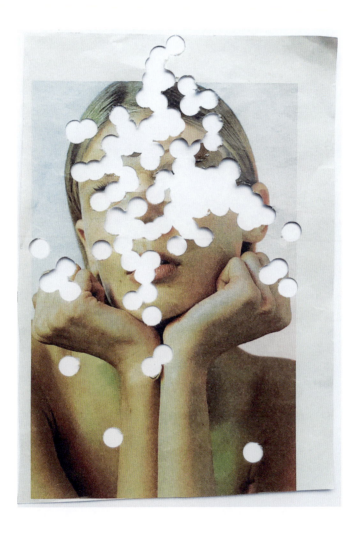

Air Head
(magazines, hole punch, glue)

10. Confetti collage

Don't waste the contents of your hole punch tray! Combine the punched-out circles (also known as 'chads') with a photographic image to create a confetti collage. Empty the contents of the hole punch tray and sprinkle them onto your collage. If you don't want to glue the 'confetti' in place, you can photograph your composition and then blow away the circles ready to start all over again. You should take care when using fixative spray, and only do so in well-ventilated places, using a mask. Check the guidelines on the can before you spray.

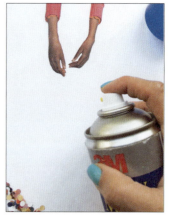

1.
Collect brightly coloured tear sheets from magazines. Don't worry about the subject – you are simply looking for textures, colours and tone.

2.
Punch away with your hole punch until you have collected lots of coloured circles in the tray. Now select and cut out another image to complement your confetti, for example, a pair of hands.

3.
Lightly spray a sheet of paper with glue in the area you want your coloured circles to fall, then randomly sprinkle the circles over this area. Allow to dry. Position the other element on the paper and glue in place. Seal the arrangement with fixative spray and allow to dry.

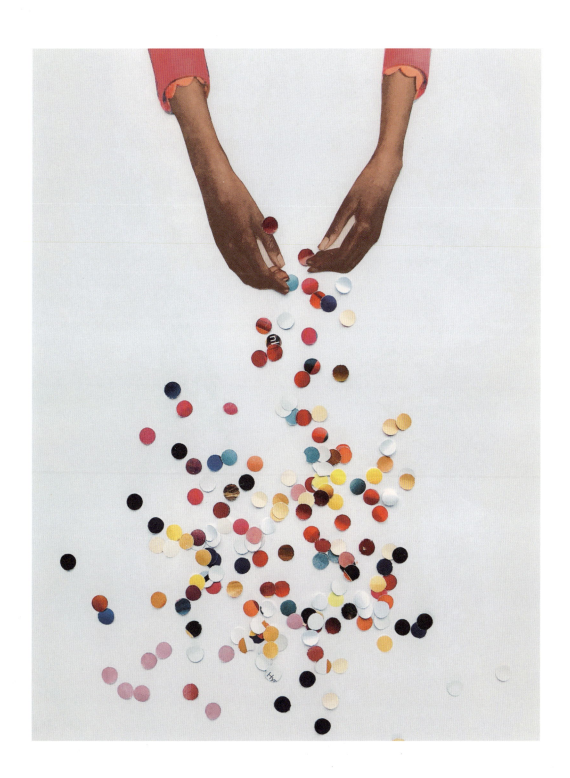

Falling
(magazines, hole punch, scissors, paper,
spray glue, fixative spray)

Texty

Typography is the visual art of creating and arranging words and letterforms. The relationship between letters and the way that they are arranged on the page can communicate a feeling or an attitude or add meaning to the composition.

Collage can utilise typography to great effect by incorporating words, letters and symbols into abstract compositions, where typographic elements are divested of their meaning and transformed into abstract shapes. Conversely, certain words can be highlighted for their conventionally assigned meaning within an image, rather than just the shapes the letters make when they are brought together. There can be a playfulness inherent in the use of text within collage, exploiting the interplay between the letter or symbol, what is usually understood by it, and the context in which it's now being used.

Try experimenting with newspapers for the texture and pattern quality of the type rather than the meaning of the words it spells out. By treating letters and symbols as mere marks on a page, you can assume their graphic qualities to capture figures, faces and expressions.

```
Text_ure
(magazines, paper, scissors, glue)
```

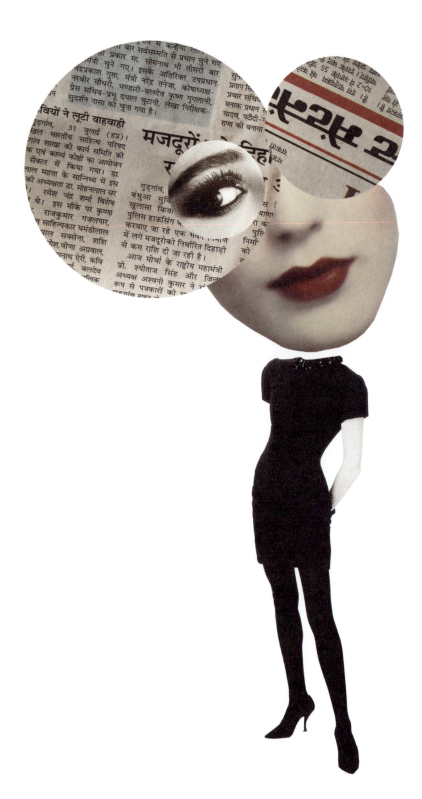

Type Texture

38 Texty (magazines, newspapers, pencil, scissors, glue)

11. Type as texture

Circles cut from pages of type can stand in for the features on a face: the resulting collage is still recognisable as the human form, but a bit more interesting. Look for coloured accents within text to enhance your composition. Here, the bold red underlines in the newsprint complement the colour of the lips and brings the arrangement together. To distract the eye from reading, text can be reversed on a photocopier so it is viewed more as a texture within the collage. You could also use a foreign language newspaper as the unfamiliarity of the words will help you to view blocks of type as pattern and texture, but if you're not familiar with the language, it's a good idea for someone who is to check what the words actually say. These are available in major newsagents; alternatively, the internet is a good source.

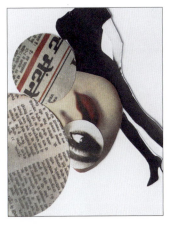

1.
Look for interesting typefaces, tinted panels and coloured underlines within newsprint.

2.
Using circular objects such as small bowls as templates, draw different-sized circles onto the selected sections of newsprint. Carefully cut out these shapes.

3.
Select and cut out a body, a face and one or two individual facial features from magazines. Play with size and proportion, such as placing an oversized head on a slender body. Combine the photographic images with circles of text, which can stand in for specific facial features. When you are happy with the composition, glue it in place.

12. Multilingual

Combine text with photography by replacing pictorial elements with typographic cuttings. Try a multilingual, monochrome landscape – foreign-language newspapers and magazines work particularly well, as we more easily see shape and pattern within an unfamiliar language. Here, text is acting as a structural element, to give contrasting texture and depth to your collage.

These soaring tower blocks of words fit well within the black-and-white concrete architectural arrangement, echoing the texture and shapes of the buildings. A monochrome foreground palette invites you to play with contrast as either a background or accent feature. Here, the black-and-white layers contrast with a bright blue sky.

 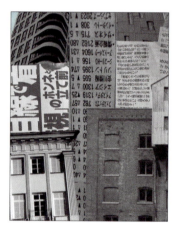

1.
Gather your urban imagery, with a mix of skyscrapers and some smaller buildings, and start to cut out and build your city skyline against a suitable background. Use the tall buildings for the background and the small ones for the foreground. Don't stick anything down yet.

2.
Collect newspapers that are in a language you are unfamiliar with. Cut newspaper blocks of varying height and shapes to imitate a city skyline. This will form the middle layer.

3.
Compose your arrangement by sandwiching the newspaper blocks in between the foreground and background buildings. Glue the images in position in order, working from the background to the foreground.

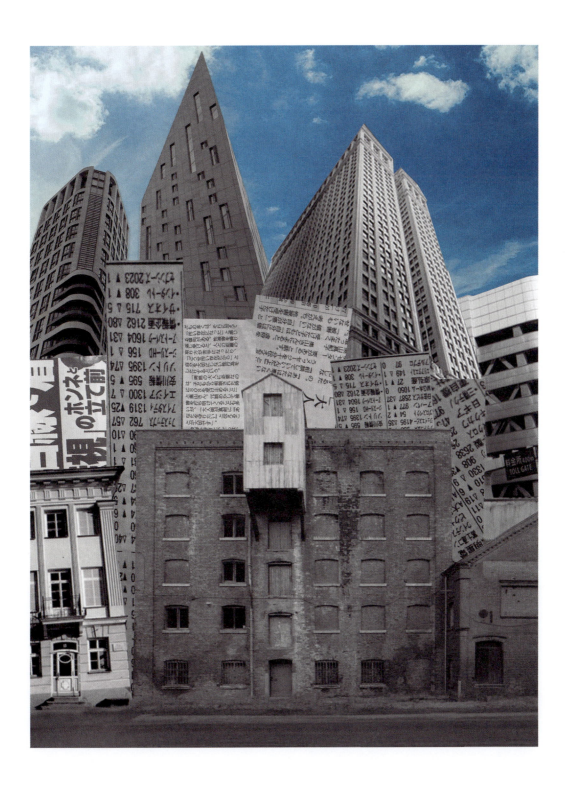

Lost in Translation
(magazines, newspaper, scissors, ruler, knife, glue)

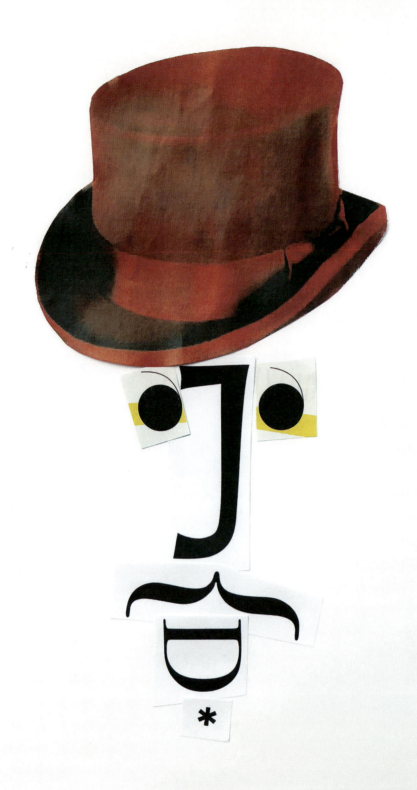

Man with the Hat
(magazines, newspapers, scissors, glue)

42 Texty

13. Features

Take the opportunity to learn a bit about typography and every time you see printed type you will find yourself considering its particular qualities. In typography, 'serif' tends to refer to the traditional and classical typefaces with flourishes on their lines and strokes, whereas 'sans-serif' fonts are usually simpler, with bolder characters. Script fonts offer a personal touch with fluid lines that are based on handwriting. Most fonts also have variations of italic, bold, light, capital and lower-case letters … and don't forget numbers, symbols and punctuation marks!

This project makes a feature of this variety. Use a collection of letters and other characters to compose a face. Consider the facial expression you would like to capture in order to determine your selection, or start with the font style as the inspiration for the face you create.

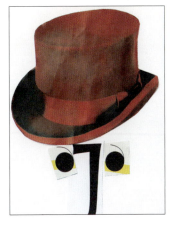

1.
Gather a selection of letters and other characters from magazines and newspapers. Look for varying typefaces in different sizes and colour, or keep it uniform.

2.
Consider which of the characters work best for the individual facial features that make up a person. Build a face with the cut-out letters and characters. When you are happy with the composition, glue it in place.

3.
Decide what sort of personality your font face has and accessorise accordingly. Here, this elegant city gent has been adorned with a found image of a top hat, which was carefully cut out and stuck in place.

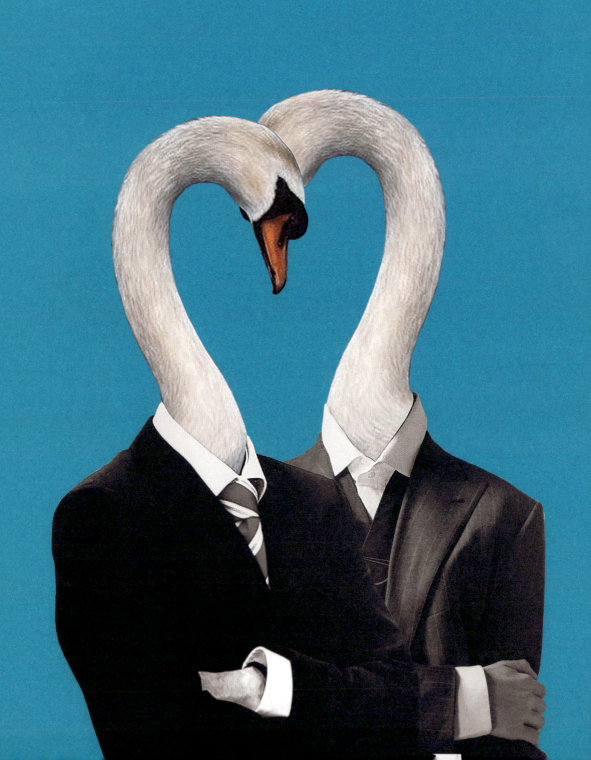

Menagerie

Whether domestic, wild or exotic, animals make fantastic subject matter for collage. Placed in an unexpected context, the unique forms animals can be exploited to various effects according to their innate characteristics and how they are interpreted. Indulge your imagination and consider the absurd: a pair of suited swans; an over-emotional moose; a menagerie of meerkats...

Simplicity is often the best option, so choose your imagery carefully and keep the collage crisp. In the example shown here, the seamless conjunction of the swans' necks and the shirt collars creates a convincing alternative reality. Use a photocopier or scanner/printer to scale an image in order to fit pieces together perfectly. Similarly, make multiple copies and flipped images to create symmetry, pattern and mirror images.

Clever or witty juxtapositions of seemingly disparate imagery, the manipulation of scale to emphasise the absurd, and the anthropomorphic qualities attributed to animals all enable a collage to tell a story. Because we attribute human qualities to animals, they can be the perfect subject matter to explore grand emotional themes such as love, companionship and loss.

```
I Dreamt I Was a Beautiful White Swan
(photographs, coloured paper, scissors, glue)
```

14. Mirror mirror

Create a collage of two halves. Compose one side of the collage and then, using a photocopier, duplicate that one side, flipping the image. Then merge the mirrored duplicate with the original – you can double the detail with mesmerising results.

 Ideally, start with a few simple images before moving on to more complex compositions. Use a mirror to check your overall image at regular intervals as the collage progresses in order to gain an idea of what the final composition will look like, or forget the mirror and let the result be a surprise.

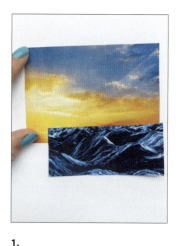

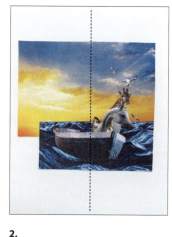

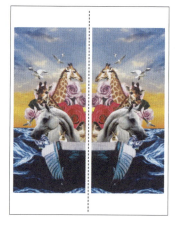

1.
Create a background for the collage using images cut from magazines, such as expanses of sky and sea. Roughly cut out the pieces and glue them onto paper. Draw a centre line through the middle of the page.

2.
Gather images of animals and any other elements needed to convey your narrative – here, a boat and bouquets of roses – and decide whether to build your collage on the left or right side of the line. Start to build your collage outwards from the line. You can try out your composition before gluing it down, if you want.

3.
Once the chosen side of your collage is complete, cut along the centre line and, using a photocopier, make a copy while flipping the image horizontally. Trim both pieces neatly and match both sides along the centre line to complete the mirror image.

46 Menagerie

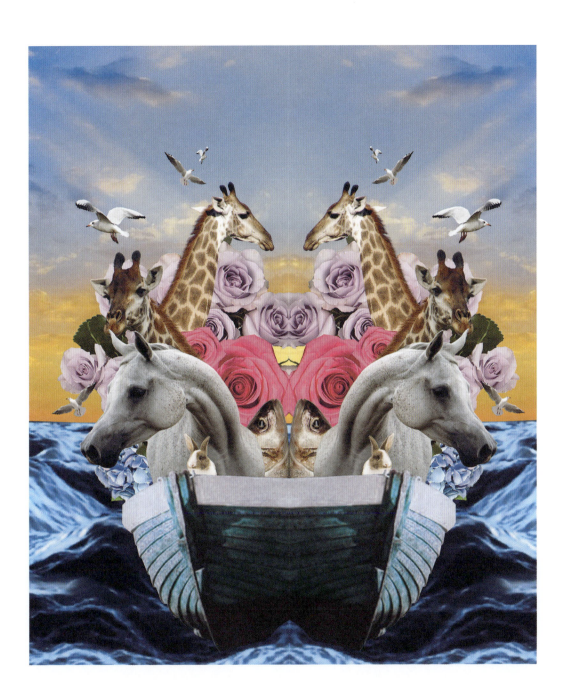

Noah
(magazines, paper, scissors, glue, photocopier)　　　Menagerie <u>47</u>

15. Anthropomorphic

Mixing cartoon elements with photography can express different – and unexpected – emotions, often with humorous effect. Dig out your childhood comics and get cutting. Cartoon features naturally integrate well with photographic portraits too, so unearth those family albums. Look to the 1960s American pop artist Roy Lichtenstein for inspiration: his large-scale works adopted the comic book style and made the most of the form's bold lines and simplified features to create exaggerated portraits and melodramatic situations – perfect for contrasting with the (usually) naturally dignified expressions of wild animals.

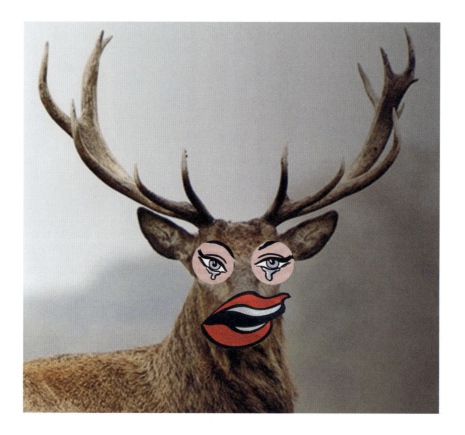

Tears
(magazine, comic, scissors, glue)

48 Menagerie

An incongruous combination of images here somehow encapsulates the personalities of both groups. They don't have to be an exact match – the eye and imagination will fill in the gaps, especially when the message is strong. Replacing the top half of a group family photograph with a comedic strip of inquisitive meerkats captures the spirit of a family on holiday.

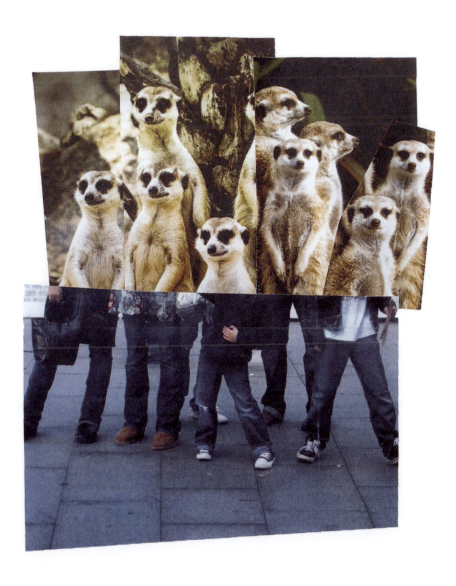

Pack
(photograph, magazine, scissors, glue)

16. Sketch

Here's a chance to practise your drawing skills: incorporate a continuous-line sketch into collage. This simple mixed-media approach – where an expressionistic brushstroke body and detailed photographic head are cleverly matched to form a whole – makes a convincing picture. The brush pen is a versatile tool that's quick and easy to work with, producing fantastic results – it enables you to mix thick and thin strokes depending on the angle and pressure you apply, and is ideal for drawing continuous lines (i.e. without taking the nib of the pen off the paper). You can either start with a photograph of a head and then sketch a body to match, or vice versa.

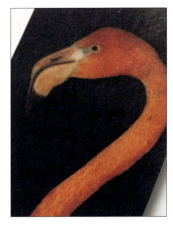

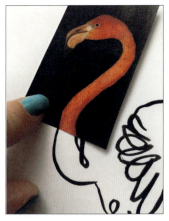

1.
Choose a photographic image with plenty of detail. Cut this out roughly or in a geometric shape and set it against a plain white background paper.

2.
Using a brush pen, sketch in any missing elements – here, the flamingo's body. Using a continuous line gives a more spontaneous result. Vary the pressure on the pen to create a mixture of thick and thin lines.

3.
Once the sketch is complete, glue the photographic image in place, making sure any joins line up perfectly.

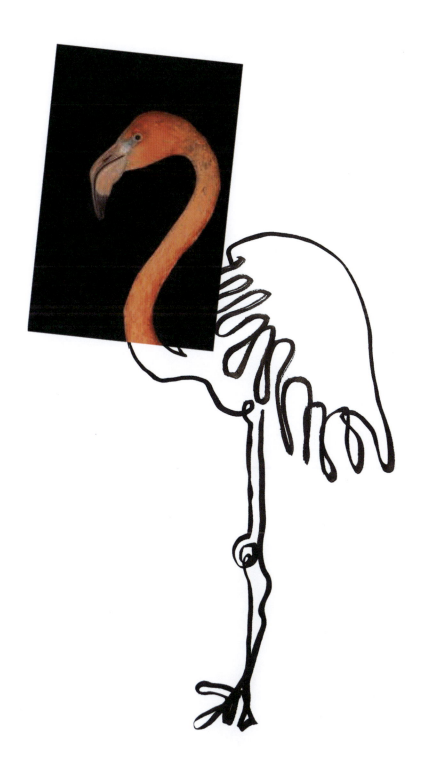

Pink
(photograph, paper, brush pen,
scissors, glue)

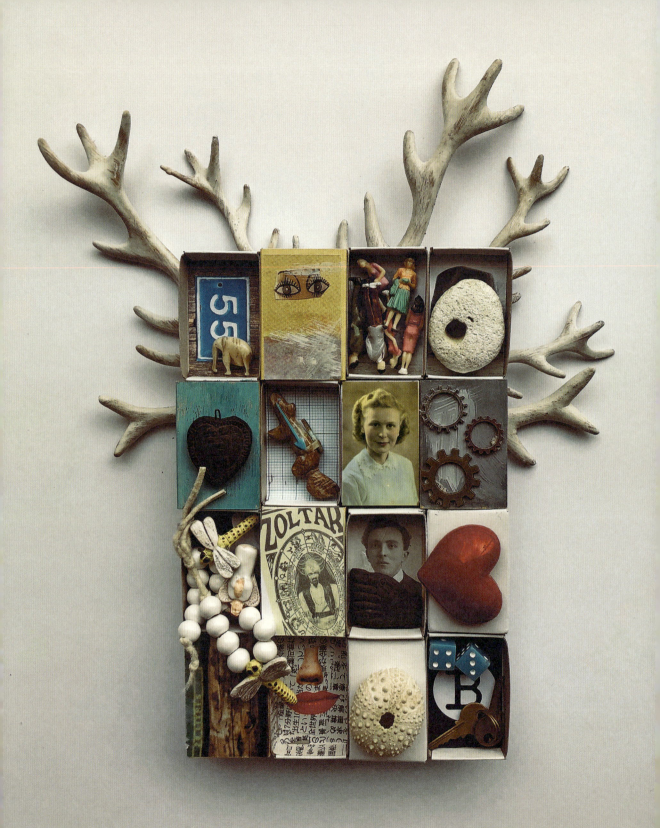

3D

Three-dimensional collage is an excellent arena in which to explore assemblage. Assemblage is art made from found objects, such as scraps of wood, fabric offcuts, rusted door furniture, broken ceramics, stones and pebbles, all fixed together – it is making something out of nothing. This three-dimensional, mixed-media approach to creating art has been adopted by many artists, including Pablo Picasso, Marcel Duchamp and Joseph Cornell in the early twentieth century. Later in the mid-twentieth century, the arte povera movement adopted the practice of assemblage, making artworks from deliberately 'poor' materials in an anti-capitalist stance against the commercial gallery system.

Create compartments made out of matchboxes and collect ephemera and decoration to fill them with, or transform a pair of old paintbrushes into a brand new artwork. Play with cards and build a face out of disconnected features. Experiment with the trickery of trompe l'oeil or let a nature trail kick-start your creative three-dimensional journey.

Hunter Gatherer
(matchboxes, photographs, coloured paper, assorted ephemera, scissors, glue)

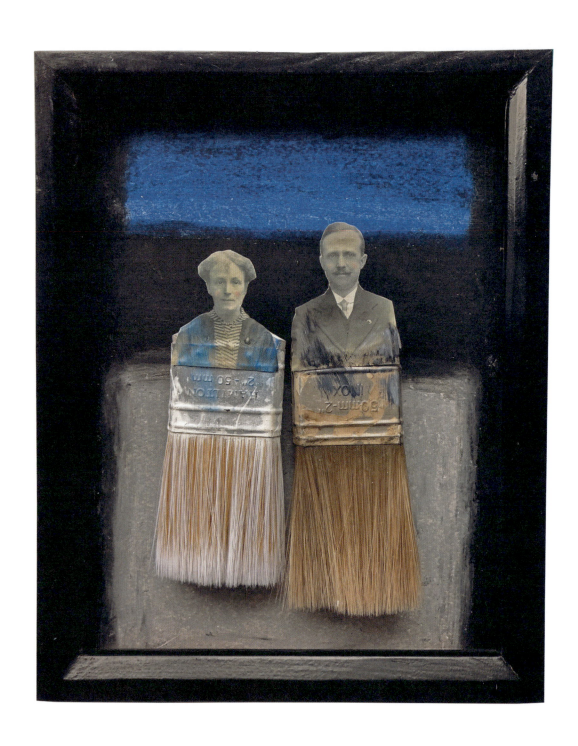

Mr & Mrs Bristle
(box frame, paintbrushes, handsaw, photograph,
paint, paper, oil pastels, scissors, glue)

17. Assemblage

Repurpose discarded objects through the art of assemblage, combining them with found imagery to create a fresh narrative. Presented in a recycled box frame, figures from the past can be reincarnated. Here, a couple of used paintbrushes found in the shed stand in for the bodies of a husband and wife in this portrait, the wooden handle and metal ferrule of the brushes mirroring the shape of their shoulders and torso. You don't have to use paintbrushes; this project will work with lots of different kinds of simple objects.

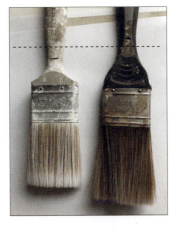 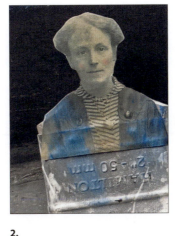

1.
Take two discarded paintbrushes, preferably with some contrast, as with the tones of these paintbrushes' bristles. Using a handsaw, carefully cut off the handles about 5cm (2") above the metal ferrules, as indicated by the dotted line.

2.
Photocopy two family portraits, enlarging or reducing the images so each shoulder width matches the width of a brush. Carefully cut out each portrait around the head and shoulders, cutting straight across the torso. Glue one portrait to each brush just above the metal ferrule. Blend the join between the portrait and the brush with washes of paint.

3.
Create an abstract textured background for your portraits with broad bands of colour in oil pastels on a heavy textured paper. Compose the assemblage in the frame by positioning the paintbrush figures centrally within the background. Fix in position with strong glue.

3D

18. Trompe l'oeil

'Trompe l'oeil' is a French phrase meaning 'deceive the eye'. Use collage to trick viewers into seeing three dimensions in a totally flat image. Be inspired by the optical illusions of Dutch graphic artist, M. C. Escher, whose mind-boggling, reality-bending artworks play havoc with spatial dimensions.

The principles of perception and perspective can easily be explored with collage: apply blocks of colour with contrasting textured surfaces to a geometric construction to give the appearance of three-dimensional shapes. Consider light and shade to enhance the illusion. Have fun and explore another dimension.

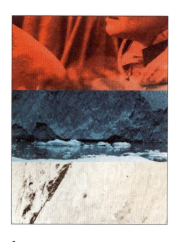 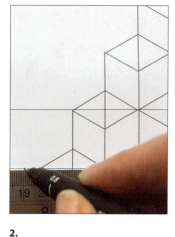 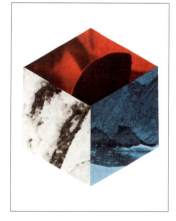

1.
Collect three tear sheets from magazines, each of a different colour and an interesting texture. Choose a light shade (cream), a dark shade (blue) and a mid-tone (red).

2.
Draw a template: start by accurately drawing a three-dimensional shape (dotted or gridded paper can help), then, using thin or tracing paper, trace it multiple times until your grid is complete. Use vertical and horizontal lines, as shown, to guide the position of your shapes. Make three photocopies. Position a template over each tear sheet and secure with masking tape.

3.
Cut out the faces of your shape and decide which will be the mid-tone, the light side and the dark side. Keep this consistent. Reassemble the cut-outs into cubes on a sheet of paper, following the template. Ensure there are no visible gaps between the individual pieces. Glue in position. Add a photographic element to anchor the image on the page.

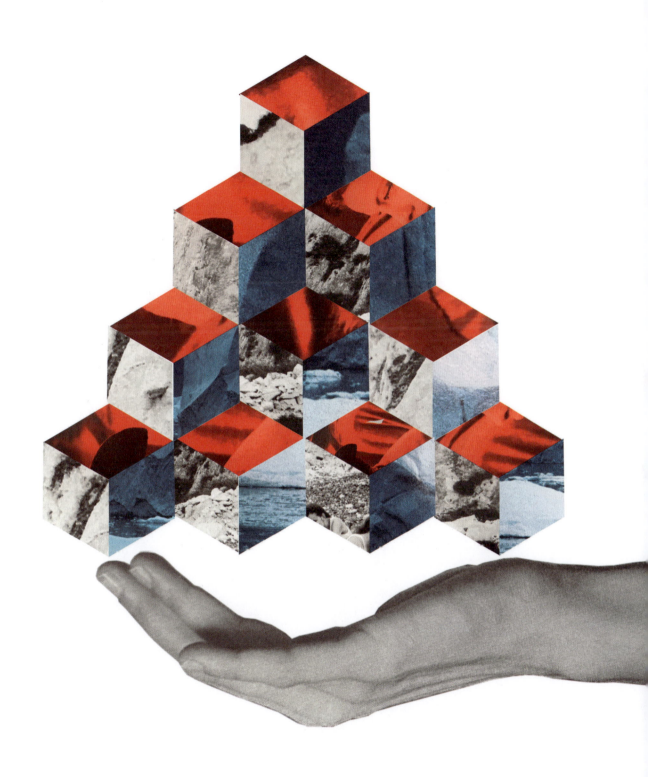

Capture
(magazines, ruler, protractor, pencil,
tracing paper, masking tape, knife, glue)

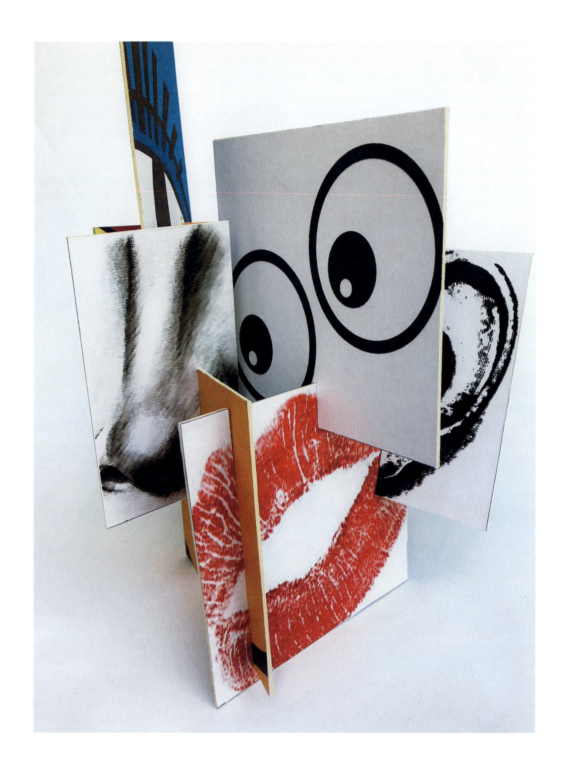

Juxtapose

58 3D (magazines, comics, card, ruler, scalpel, glue)

19. Juxtapose

Create a set of interlocking cards that you can slot together in a three-dimensional construction to form an abstract face. Take inspiration from the deconstructed portraits of Pablo Picasso, in which front and profile views are combined on one plane, and juxtapose features in compositions that intrigue and yet remain legible as faces. Mix different styles of imagery, such as graphic photographs, cartoon faces and etched portraits, so that the varying angles and elevations always give an unexpected juxtaposition of elements. Make as many different cards as you like and keep shuffling and restacking the cards, then capture each unique composition with a camera.

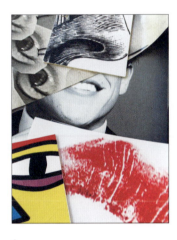 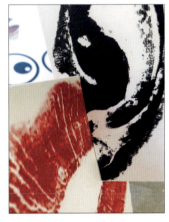

1.
Gather as many different features as you can find from magazines and comics, each in an interesting style – photographic, painted or drawn. Cut out each feature and mount them onto card. Squares and rectangles will work best, but feel free to vary the size and shape of the cards.

2.
Cut a slit either in the centre or along one edge of each card, so they can slot into each other. Make the slits the same thickness as the card. Consider the best position for each slit depending on the facial feature – for example, a slit on the inner edge of an ear might work better than on the outer edge.

3.
Build your three-dimensional portrait by slotting the cards together. The depth of the slits will affect the way the pieces connect, so play around with the height of each card until the features are where you want them – you can always adjust the depth of a slit by cutting it again.

20. Earthy textures

Land artists, such as Richard Long and Andy Goldsworthy, work within nature to create temporary artworks. The land art movement emerged in the 1960s and 1970s, exploring art through many different organic materials, both living and decaying, with the transient artistic outcomes captured only through photography. Look to the natural world for inspiration for your collage and combine earthy elements with photographic images of nature cut into geometric shapes. Respect the environment and collect responsibly, taking care not to disrupt habitats or vandalise private property. Be on the lookout for interesting colours and textures: burnished golden leaves, peeling bark, smooth pebbles, cracked earth, and so on.

1.
Venture outdoors to collect your natural collage pieces. Parks and fields, woods and forests are sources of organic matter, but don't overlook your own garden. Respect the environment and any wildlife while you do this. Photograph anything you can't take home and look in magazines for additional textures.

2.
Design a geometric shape and draw it in fine pen onto paper to use as a template. (Use the above template, enlarged on a photocopier, if you like.) Make plenty of photocopies. Position a template over each material or photograph and secure with masking tape. Cut out different sections from each material.

3.
Transfer the cut-out materials onto a sheet of white paper, piecing them together to form the geometric shape. Aim for an alternating mix of real and photographed materials. Make sure there are no visible gaps between the individual pieces. Glue it in position.

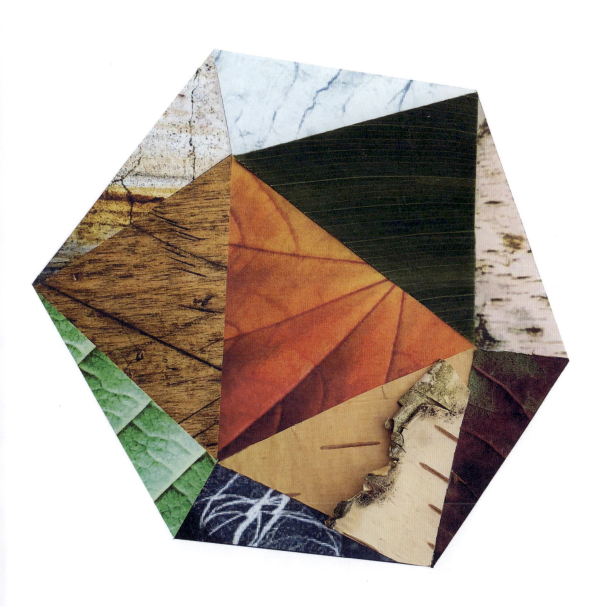

Earthy Mix
(bark, leaves, magazines, knife, glue)

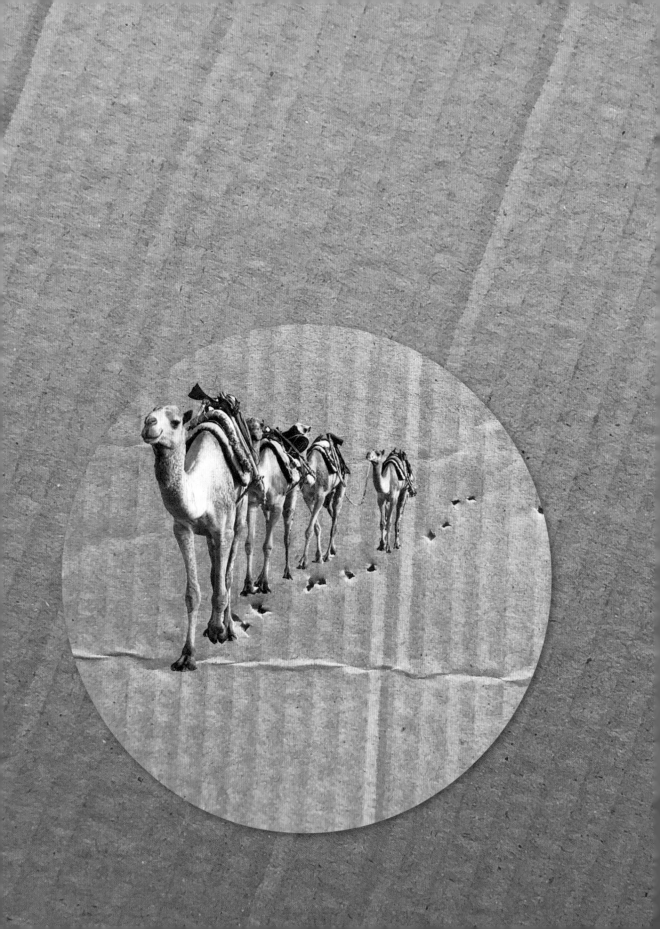

Canvas

The material you choose for the background to a collage can be as important as the subject of your artwork, so consider your canvas carefully. Whether it is newspaper, corrugated cardboard, old cloth-covered books, plywood, fabric or printed materials such as playing cards, advertising posters or plastic bags, a judicious choice of canvas can integrate the collaged elements to unify the overall idea and strengthen the narrative.

Rather than creating a collaged image and then mounting it on white paper, select a background material and use that as the creative springboard for your collage. Whether you re-purpose a discarded object or recycle old packaging, be inspired by the base. Corrugated cardboard is a perfect canvas for a camel train, for example. The ridges in the cardboard imitate the blown sand dunes of the desert, the colour and texture of the sand echoed by the raw qualities of the corrugated card. Holes punched with the point of a skewer make convincing camel footprints in the sand and add further texture to the piece. Harness the qualities of a material and allow them to spark your creativity.

```
Camel Train
(corrugated cardboard, vintage magazine, scissors, glue)
```

21. Recycle

From battered cloth-bound covers to faded inside text pages, old books make great canvases. The dappled, stained endpapers inside the cover of a book suggest the decaying plasterwork of ancient buildings. Add architectural details, such as an entry gate, a portico and shuttered windows. With carefully selected imagery you can tell a story through even the simplest composition. Stretch your imagination and add further details. Perhaps there is someone peeping out from behind a window?

Of course, you can always do this on an undamaged hardback book instead. Why not leave a personal touch on a book you're giving as a gift?

1.
Start with a suitable book. The older and more battered the better. Look for interesting marks of ageing: stains, threads and torn edges. Detach the back cover – tears and all – from the spine of the book. Alternatively, leave the book intact and add a surprise to the inside back cover. If it's a new book, perhaps your collage will be inspired by the subject matter.

2.
Search magazines for interesting architectural elements of varying styles, including a collection of colourful windows. Carefully cut these out.

3.
Position the cut-outs of the architectural features on the endpaper of the book cover. Place an entranceway, portico, or pillars in the lower half, then add a selection of windows, balconies or spires in the upper half. When you are happy with the composition, glue it in place.

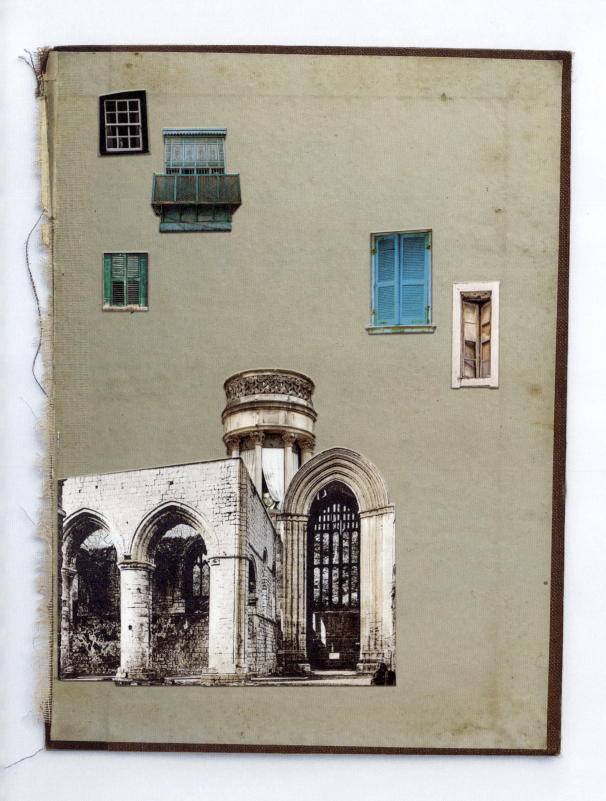

Hardback
(old book, photographs, magazines, scissors, glue)

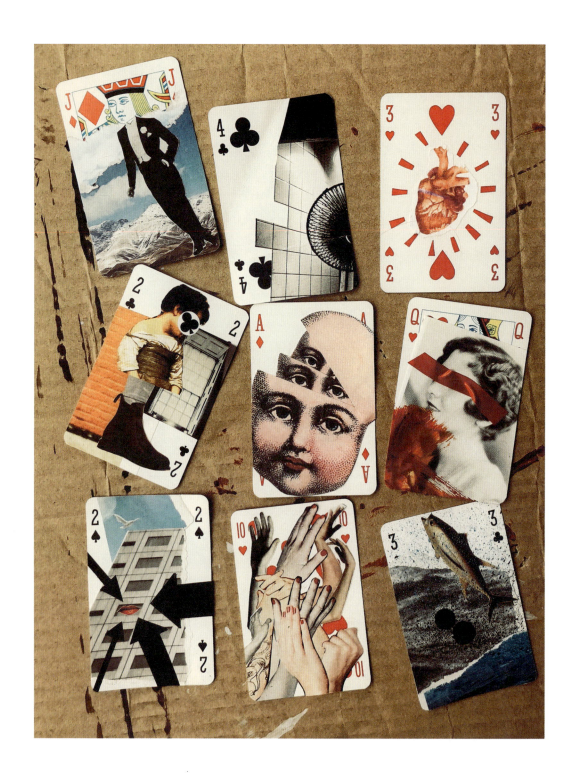

Suits

66 Canvas (playing cards, multimedia, scissors, glue)

22. Suits

Playing cards provide a whimsical canvas for collage. Shuffle the deck and deal yourself a hand of random cards or select a single suit. Use the imagery printed on the card as the inspiration for your collage, embellishing each card by responding to its design; something the number, suit, colour or picture suggests to you. Think about how to display them, whether as a set or individually.

When creating your collage, use a mix of media and techniques from throughout this book: cut, tear, tape, paint, play with perspective, create fantastical creatures, embrace the absurd, stretch your imagination. Here are some ideas to get you started.

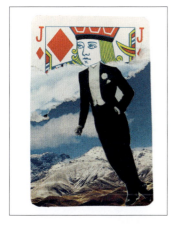 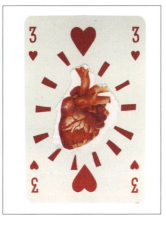 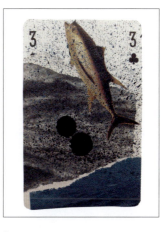

1.
Respond to part of the image on the playing card and morph it with another image cut from a magazine. Here, the Jack of Diamonds is a wealthy playboy, dressed in black tie while in a mountain range.

2.
Take inspiration from the suit and make your collage a play on words. Here an anatomical heart transplants a graphic heart.

3.
Break the limitations of the card and set your imagination wild. Perhaps you'll let the number-and-suit combination suggest something through free association. Here, splashes and paint drips echo the watery fish and sea-themed imagery.

Canvas 67

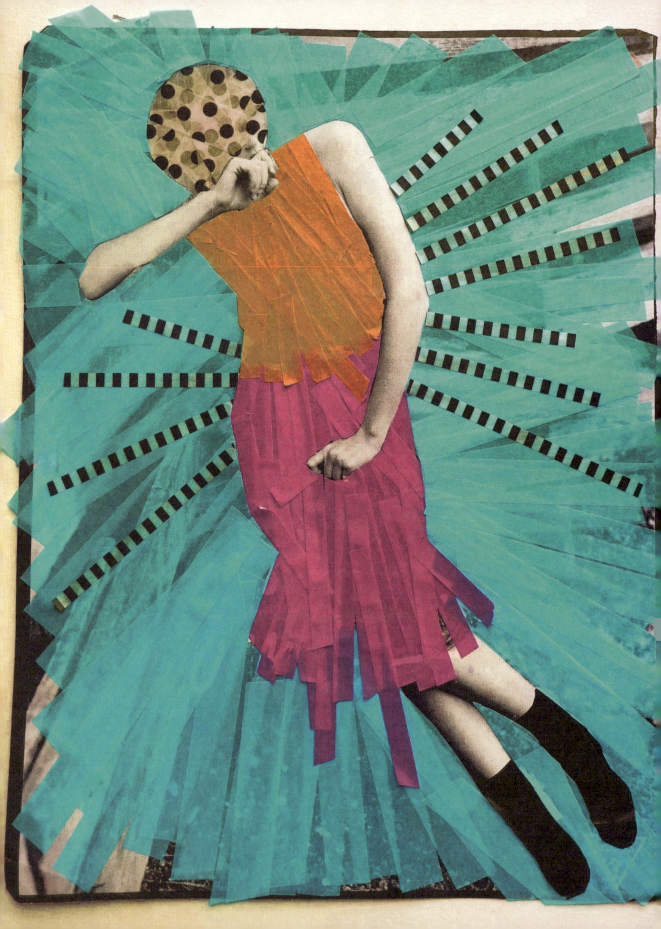

Washi

Washi tape is wonderfully addictive. It can be used for decorating anything and everything. A Japanese paper tape, it is usually made from the inner bark fibres of the gampi tree or the paper mulberry bush. The term washi comes from the Japanese words *wa*, meaning Japanese, and *shi*, meaning paper. Because it's so durable, traditionally it has a huge range of uses, from origami to clothing.

In its tape form, washi is great for creative contemporary collage; it comes in a vast array of colours and patterns, including neon and metallic, and its linear form makes it perfect for a graphic approach. The beauty of washi tape is its versatility – if applied gently and carefully, it can easily be removed if you need to reposition it. Alternatively, you can add more strips to build up layers and texture.

Layer patterned washi tape over sepia-toned vintage photographs or embolden fashion imagery from magazines with lines of zippy colour and pattern. Build up texture with overlapping strips of tape, or work with an existing image, choosing certain areas to leave exposed beneath your washi layers.

Boom
(magazine, washi tape, scissors, glue)

23. Washi pattern

Vintage photographs make ideal canvases for cladding in patterned washi tape. By covering the majority of a photograph or image with patterned tape, leaving only certain features bare, a focal point is created. Choosing tape in such lively patterns lends personality to the subject of the portrait here: his sober dress is made decorative and a little bit eccentric. The regular dots in the pattern sequence, combined with the fabric-like layering, add a rich texture to the surface of the image, and a pop of colour completes it.

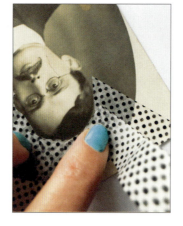

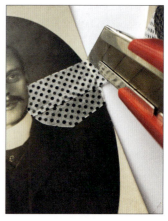

1.
Choose a photograph or an image torn from a magazine. It can be of any subject you like, from a portrait to a landscape. Next, make your washi tape selections. Choose bold colours and patterns that work together.

2.
Decide which areas of the image to leave clear of washi tape. Now, using strips of tape, cover the other sections of the image with pattern. Vary the direction of the strips of tape, laying some across another to build up layers of pattern.

3.
Scissors are ideal for making simple straight cuts, but for any trickier cuts around intricate shapes, use a scalpel or craft knife as you can be more accurate. Or for a freehand look, washi tape can be torn by hand.

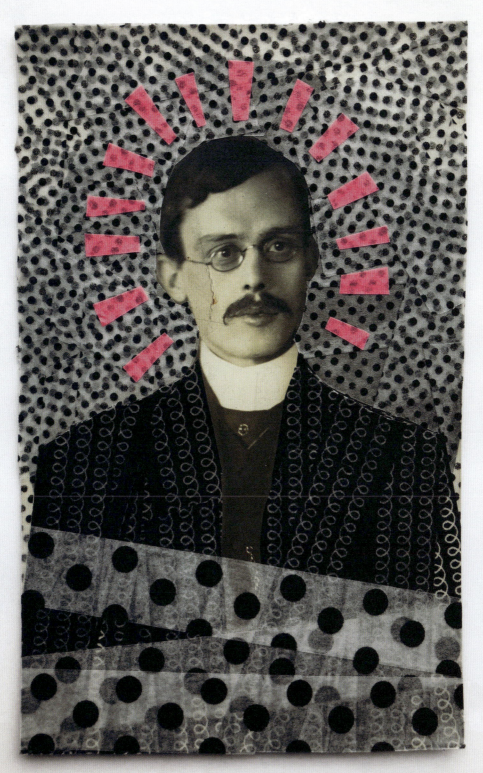

He's Very Black and White
(photograph, washi tape, scissors, scalpel)

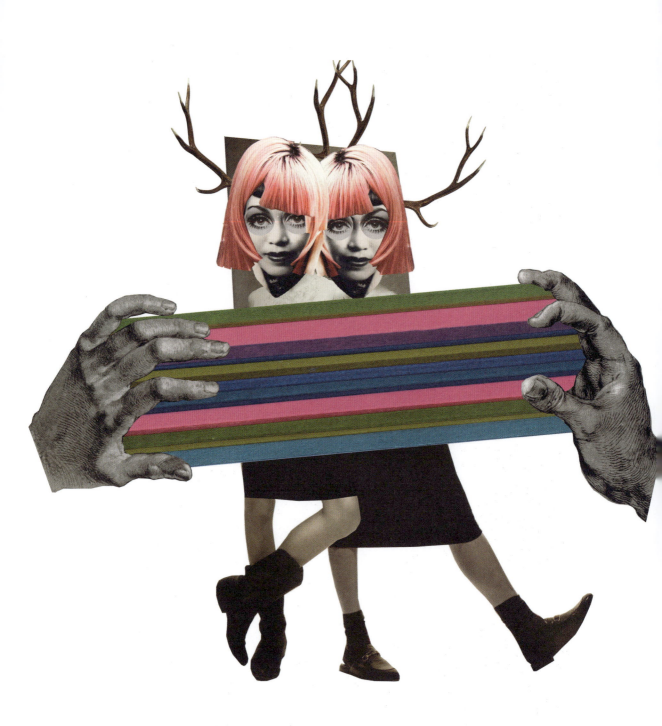

Telepathy
(photograph, magazines, photocopier, coloured paper,
washi tape, scissors, glue)

24. Washi layers

Give your composition a sense of depth by adding a washi-tape foreground. Working in layers, start with a base collage, then apply washi tape over the collaged image, finishing off by adding another collage element or image on top. A washi sandwich!

1.
Create your base collage. It can be anything you want, but consider where your washi block is going to go. Here, twin girls have been made from a variety of cut-out pieces – some copied to create a mirror image – all patchworked together.

2.
Add a second distinct layer to the collage using washi tape. Choose a selection of colours that work with your base image and stick the tape directly on top. Overlap the tape to vary the width of the lines.

3.
Add the final top layer to the collage to complete the illusion. For my collage, this was two hands carefully sized, cut out and positioned to appear as though they are gripping the block of washi-tape stripes.

Surreal

Combine images from magazines and photographs in unexpected ways to create worlds and scenarios that are possible only with paper, scissors and glue. Bend reality – and minds – with your collage! Surreal collage is restricted by nothing but your imagination.

Look to Max Ernst, René Magritte and other pioneers of the Dada and Surrealist movements for inspiration. These artists shook off the confines of the rational mind to explore the subconscious, which they believed to be a truer representation of the self.

Surreal collage employs the simple but effective technique of juxtaposing a number of elements that do not ordinarily belong together. Recast in an unorthodox context, they seem to take on an alternative significance or curious meaning. Seize the chance to combine seemingly innocuous imagery within humorous or thought-provoking compositions. The merging of disparate imagery into one peculiar scene transforms the original meanings of the parts, and can create startling and exhilarating pictures.

Balancing
(photograph, magazines, scissors, glue)

25. Thirds

Combine three strips of imagery into a single composition. The central piece holds the main thread of the narrative, while the imagery above and below provide a context and expand the story. To create a strong composition, choose complementary colourways and consider vertical and horizontal contrasts between the images.

War and Peace
(magazines, scissors, glue)

26. Transformation

Swap objects for body parts and create a visual story that fascinates. A clever choice of imagery can add meaning, each part contributing to the story. Look for shapes and symbolism in your replacements. Here, a cup and saucer mimics a ballerina's tutu, recognisable as such when used in combination with a ballerina's legs. On top, a captured and captivating gaze conveys more than a whole face might.

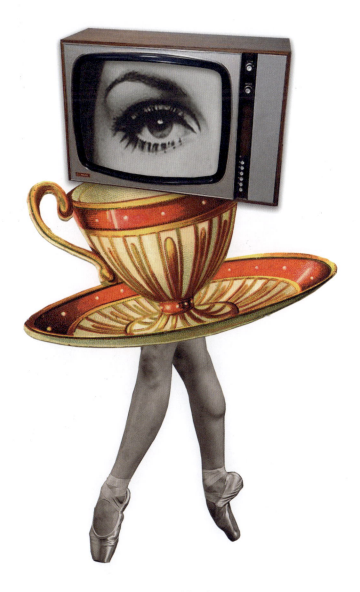

Ballerina
(photographs, magazines, scissors, glue)

Surreal 77

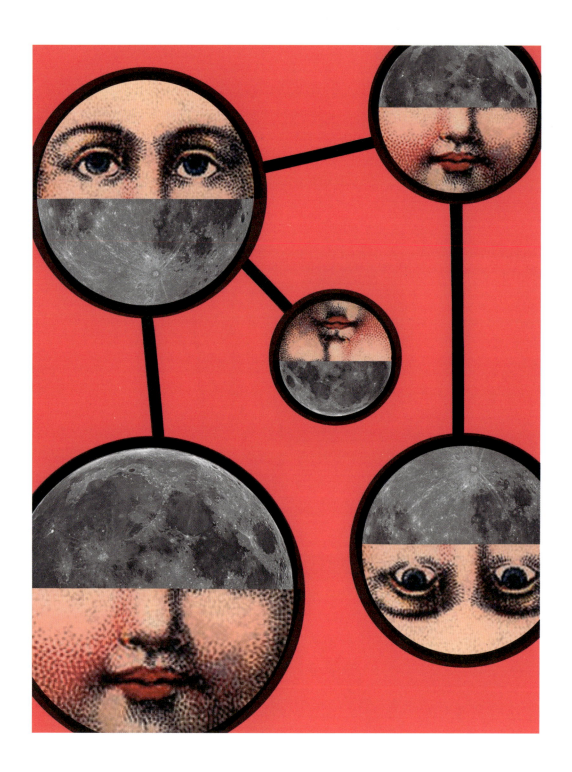

Moonface
(magazines, photocopier, scissors,
glue, black paper, black tape)

27. Split and repeat

Find two similar-shaped images to split and combine in multiples, forming an abstract pattern. Vary the scale and orientation of the images and seek to achieve balance within your composition as you arrange it. Balance means that the elements of the composition are well distributed so that no one item or area overpowers the rest, and the overall effect is pleasing to the eye.

Here, linking the elements together with interconnecting lines of tape creates a planetarium-style pattern arrangement. The strong lines add an extra dynamic to the arrangement, giving the eye a path to follow, and a bright background colour can strengthen the composition.

1.
Choose two images with a shape in common (circles are a good shape to begin with). You might need to scale them up or down on a photocopier to get them to match. Cut each image in half using scissors or a knife and ruler, as shown with the dotted lines.

2.
Stick two different halves together to make two new wholes. Duplicate the images a few times using a photocopier, varying the sizes.

3.
Mount the shapes onto black paper and cut round each shape, leaving a border on each to help define it. Arrange the images on a coloured background and stick them in place. Link the images together with black tape lines of the same width as the borders to form a connecting pattern in an abstract arrangement.

Surreal 79

28. Humour

The combination of two photographs can produce results that are literally out of this world. An impossible scenario can inject humour through the absurdity of a situation. Brenda looks a little bemused as she opens the caravan door in the morning to look for Tony… but where's he gone? Look through your family photographs for funny expressions, extreme scenery, unusual props, anachronisms, etc.

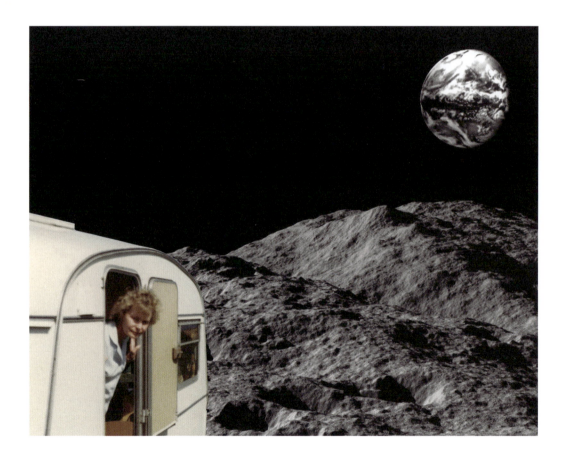

Tony?
(photograph, magazine, scissors, glue)

80 Surreal

29. Upside down

Create a collage from either related or opposite images that can be viewed either way up, rather like a playing card. Here, a bizarre mash-up of arms and legs with blending skin tones forms a continuous loop that takes the eye around the composition. Look for poses or gestures that make interesting shapes – the key is to ensure that the elements within your images are of a similar thickness so that they fit together to create the illusion of a continuous piece. Use a photocopier to scale the images up or down to help with this.

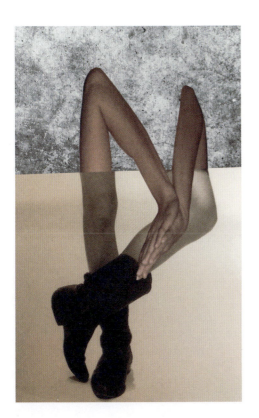
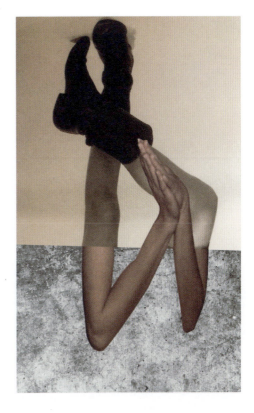

Upside Down
(photograph, magazines, scissors, glue)

Surreal 81

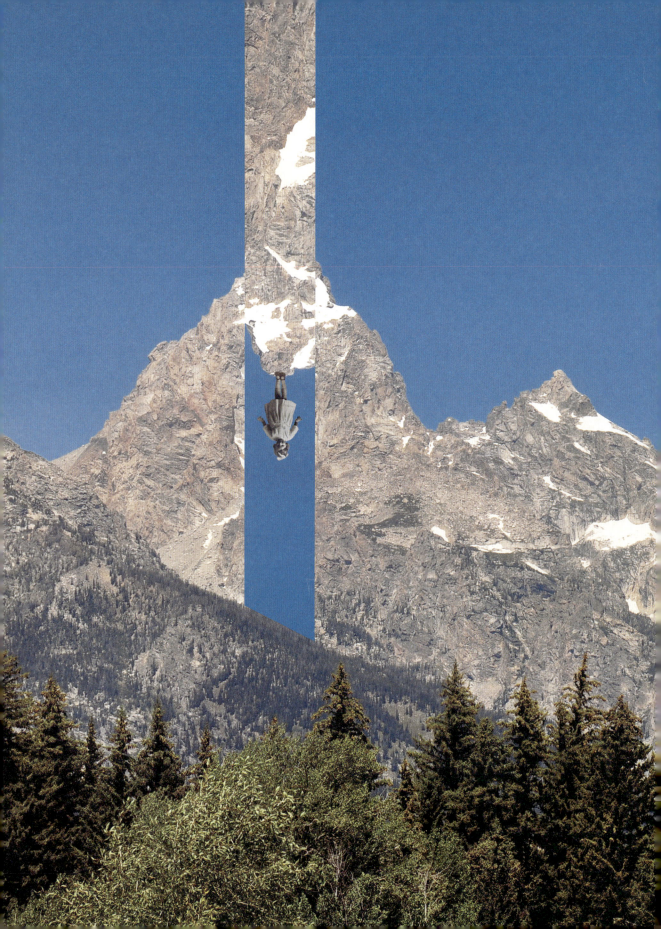

Distort

The slightest shift in perspective can distort an image enough to make you reconsider what you are seeing and look at a scene with fresh eyes. Cutting, copying and repositioning elements, or turning an aspect upside down, turns a simple scene into a more complex and interesting one.

Slide a single slice out of a mountain scene and return it out of position to reveal a figure contained within – like a game, rewarding the eye with a striking surprise. The slide-and-shift technique is simple but effective.

Raid your holiday photos for simple compositions with a large expanse of scenery, such as mountain ranges, seascapes, rolling hills and long, winding roads – these all give plenty of surface area to work with.

Hidden in the Teton Mountains
(photographs, scalpel, ruler, glue)

30. Tessellate

Dividing part of an image into random geometric sections and then swapping up and scrambling the images within this can create an interesting abstract composition. Use a photocopier to enlarge the visuals in some of the sections, and turn some pieces upside down to give the scene even more of an uncanny, alien effect.

 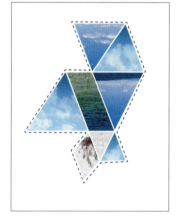

1.
Choose your main image and make photocopies of it. You can also collect a few extra images to add, either related to the main image or completely unrelated.

2.
Devise a framework of geometric, tessellating shapes to use as your template. This pattern will form the centrepiece of your collage. Draw this shape with a pen and ruler onto a piece of tracing paper so that you can place it back over the original image any time you want to check the position. Copy your template a few times onto tracing paper.

3.
Place your tracing paper on top of the photocopies and cut out pieces to fit, considering crop and size. Then, following the template, glue all your pieces in position on white paper, leaving a narrow space between the shapes. Cut around the outer shape leaving a white border. Glue the shape in the centre of your image.

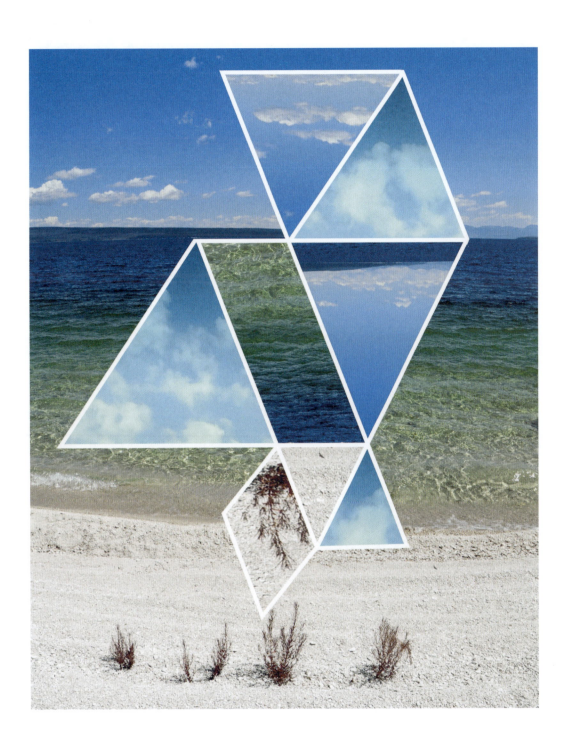

Divided
(photograph, magazine, photocopier,
ruler, scalpel, glue)

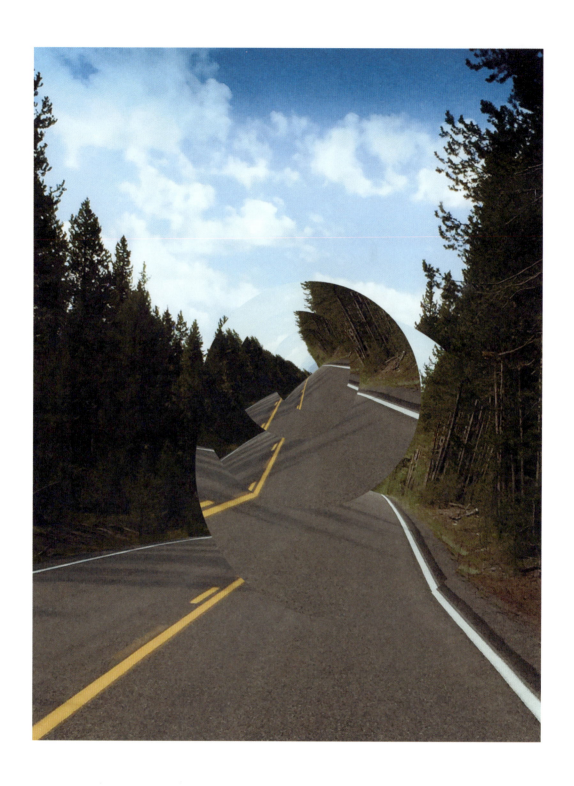

Road Trip

86 Distort (photograph, photocopier, scalpel, glue)

31. Spin

This is one image taken for a spin! Choose an image with clear lines of perspective, such as an open road, and decide on a focal point – perhaps the vanishing point of the road on the horizon. With a few simple cuts and twists, you can distort inject movement into a static image to give a rollercoaster of a composition that might suggest anything from alien abduction to a never-ending journey.

1.
Pinpoint the focal point of your image and, using a compass or a circular object and a pencil, draw a circle. (You might want to make a photocopy of the image first.)

2.
Carefully cut along this line using scissors or a craft knife on a mat. Use the photocopier to produce three increasingly scaled-down versions of the circular image to make four in total. Cut them all out.

3.
Lay your circular images on top of your main image. Position the circles one on top of the other, getting progressively smaller towards the centre of the focal point, twisting them alternate ways as you go. When you are happy with the composition, glue the pieces in place.

Distort 87

32. Stretch

Create a dramatic focal point with a repeated, staggered image. The fragmented pieces of an image are carefully positioned to give the illusion of moving upwards and stretching. Combined with a dynamic pose and a suitable colour palette, this will make a powerful image. Notice how, here, the triangles point towards the red lips, a striking flash of colour. The black background highlights the white borders and emphasises the focus.

1.
Draw a triangular template with a pen and ruler onto tracing paper. Choose a strong image, such as a model in a striking pose. Select or add an interesting focal point – like the red lips added to this originally black-and-white image – and make six copies of this collage.

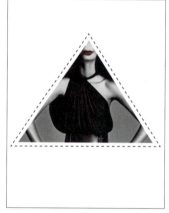

2.
Lay the template over a copy of the collage and select an area to be your focal point. Moving slightly down the image each time, cut six triangle sections and then mount each onto white paper. Cut around each triangular image, leaving a narrow border of white paper.

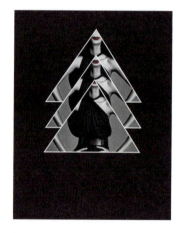

3.
On a black paper background, overlap your triangles, starting at the top and working down. Arrange the pieces in a chevron pattern by staggering the sections to create an elongated version of the original image. Place a black paper triangle over the last triangular image to enhance the chevron shape (see opposite). Glue them all in place.

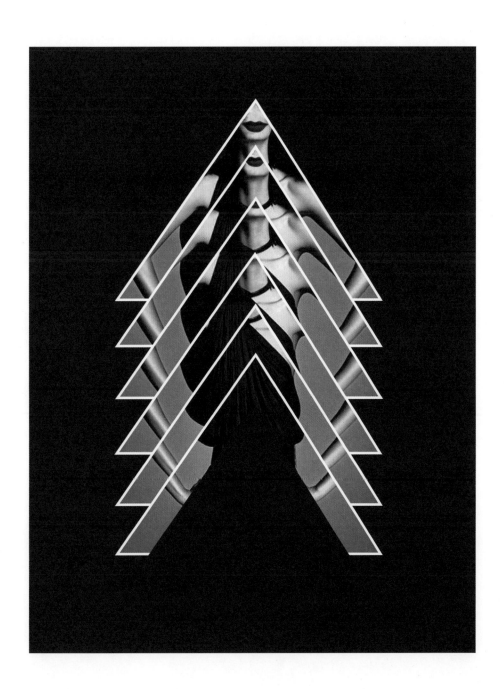

Stretch
(magazines, photocopier, paper, pen,
ruler, craft knife, glue)

Pattern

Amazing colours, textures and details can all be found in the pages of a magazine. Exploring pattern within collage is a way of having fun with geometric shapes that either repeat or interlock, and at the same time it challenges you to always be considering the interplay between colours and textures. Select sections of fabric, faces, buildings, typography – anything that looks interesting to you – and then you just need to think about how to use them.

It might be as simple as a grid of rectangular shapes, grouped by colour, tone or detail. Or how about building up ever-expanding outlines to create a contour or aura-like effect? Maybe the pieces you choose will be random and incongruous, or perhaps they will reflect a coherent subject matter. This is the start of your journey through pattern.

Abstract
(magazines, scalpel, ruler, scissors, glue)

33. Aura

Follow the edges of a chosen image to create contoured layers of organic, abstracted forms. Here, the figure of a young girl cut from a vintage photograph is accentuated by an aura of coloured papers. As the layers build, the outline grows and softens, becoming curvier and more relaxed. Using pages torn from a magazine leads to a mix of random colours, adding to the organic nature of the piece; or perhaps you will be inspired by the source image and choose colours and layers that are relevant to the subject, to give them an 'aura' that fits.

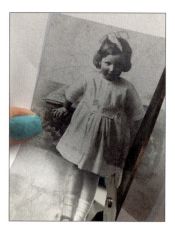

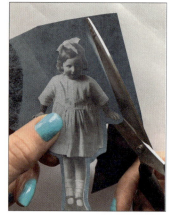

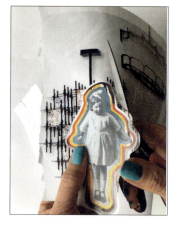

1.
Select an image and carefully cut around the outline. A black-and-white image makes an especially effective centrepiece for a colourful composition.

2.
Collect 15–20 pages of varying colour, texture and pattern from magazines. Apply glue to the back of your centrepiece image and stick it onto the first magazine page with the chosen side face up. Following the shape of the centrepiece image, cut the page leaving a slim border.

3.
Now apply glue to the back of the cut-out shape, stick it onto the next page and cut around it again. Repeat until all the magazine pages have been used and your collage has grown in size. When the image is complete, glue it onto a coloured background.

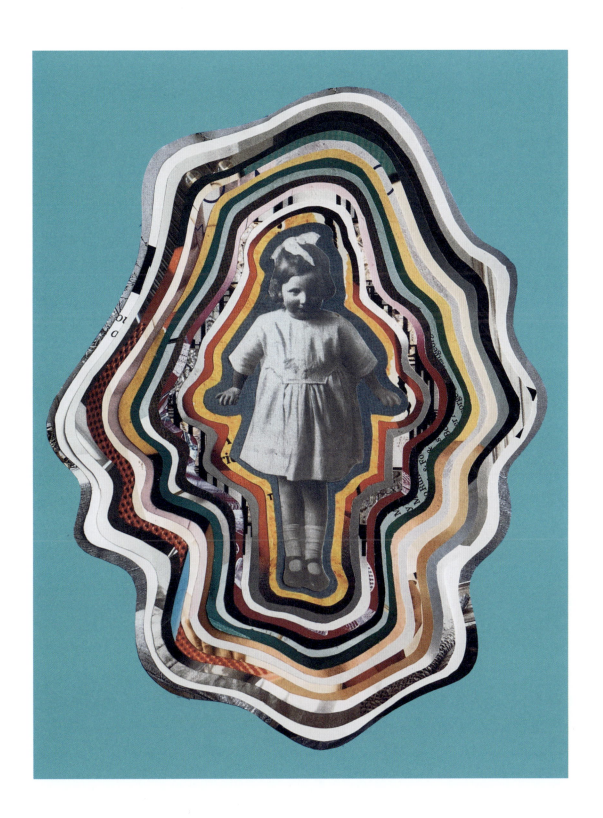

Aura
(photograph, magazines, scissors, glue) Pattern 93

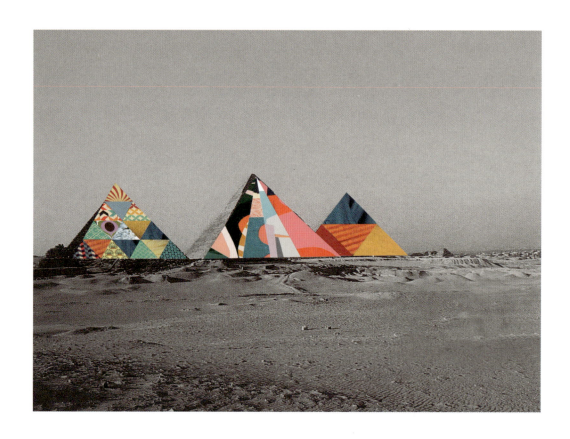

Cairo
(photograph, magazines, photocopier,
scalpel, ruler, scissors, glue)

34. Pyramids

Apply pattern to an existing image using interlocking shapes. Identify clear shapes within your image to replace with pattern and create a template to fit. Replace parts of an iconic landmark or rework one of your own travel photographs. Include plenty of detail, colour and texture in your design. Below are some simple templates based on the triangular shapes used to replace the Egyptian pyramids in the image opposite.

First, choose an image and design a template to overlay on the scene (see below). Follow this template to collage new pieces together in myriad colours, then apply them to the image. You could use any shape or combination of shapes: combine hexagons, pentagons or rectangles to form a tessellating patchwork design. Work on your patterns on a larger scale than the main image, then resize the finished designs on a photocopier to fit – this allows you to produce more detailed work without having to struggle with small, fiddly pieces. Cut out your patterns and glue them in place.

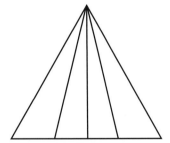 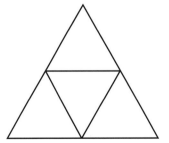

Pattern 95

35. Scene within a scene

Create a montage of natural elements, including imagery of trees, grasses, desert sands, rock formations, to convey the feeling of a landscape rather than a realistic visual representation of one. Here, for example, a mountain range is composed of sections of photographs taken while I was travelling. The glimpses of rocky outcrops, pine forests and meandering pathways all work together to capture the bigger picture. The resulting collage may not be an accurate representation of a mountain range, but it encapsulates surfaces, texture, colours and details from my experience of the landscape.

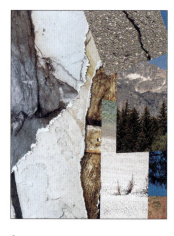

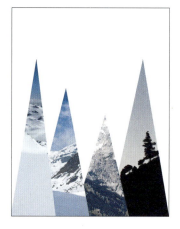

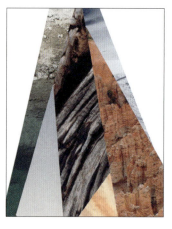

1.
Collect a mix of tear sheets and/or print out photographs of interesting surfaces that are part of a larger natural landscape. Perhaps you could go out with your camera and make a photo hunt part of the project, and, when it comes to thinking about the shape or design of the bigger scene, be inspired by the things you've found.

2.
Cut the main shapes of your scene out of the tear sheets or photographs – four simple triangles to form a mountain range, for example. This will be the base of your collage. When you're happy with the formation, stick it in place on top of a white background.

3.
Cut triangles and other geometric shapes from interesting sections of the tear sheets/photographs and work into each of your main shapes to create a patchwork design. When you're happy with your arrangement, glue the pieces in position on a piece of white paper or card. Using a plain background keeps the focus on the scene.

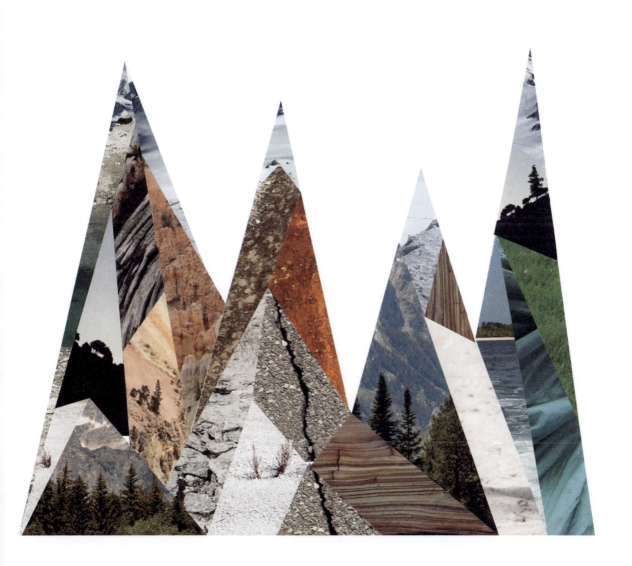

Bigger Picture
(photographs, pen, scissors, glue, card) Pattern 97

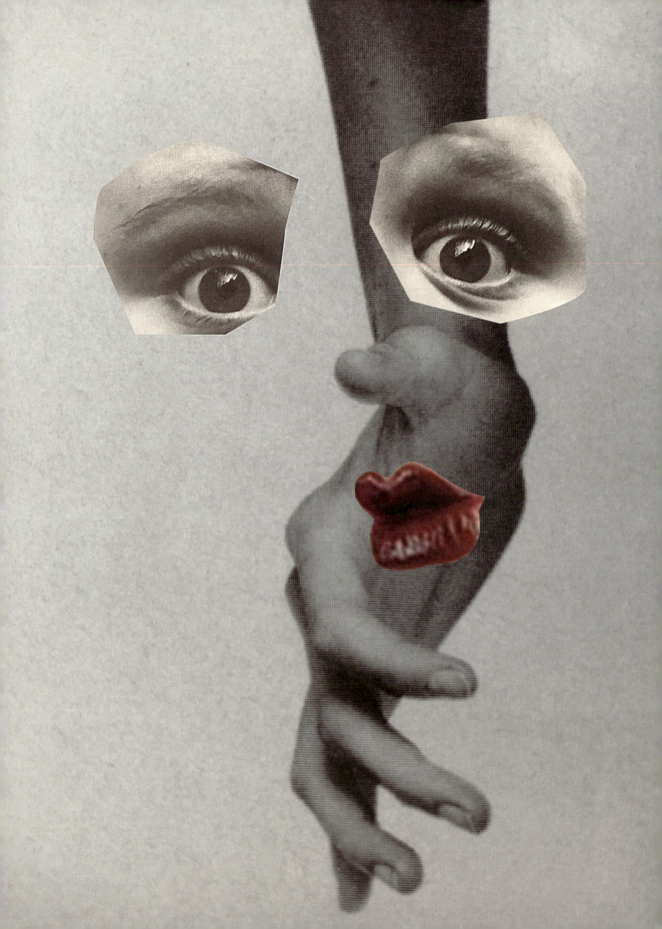

Persona

A regular portrait may tell you what a person looks like, but it doesn't always reveal the personality of the subject. A portrait made from a collection of collaged facial features – or unexpected elements that stand in for features – conjures up a unique persona. From a face made up of carefully placed features that don't really belong together, yet somehow make perfect sense, to a clever mash-up of a portrait and a statue, collage is a fun medium for creating characters.

It's limitless to how much information you can convey, and it's easy to suggest emotion through exaggerated gesture and pose. The vintage-looking collage opposite combines desperate eyes and a pointy nose to suggest a vulnerable character who's been surprised or shocked. The choice of media also contributes to the impression of a personality – the old magazines and publications lend a Hitchcockian feeling with their slightly blurry definition, harsh contrast and printing processes exposed; sharper, more modern imagery might tell a different story.

Palmistry
(magazines, scissors, glue)

36. Human combo

With collage you can play at being a cosmetic surgeon with no parameters, slicing and reworking the human form to alter an expression and change a personality, or combining different races, genders and ages together within one image to convey a message. A considered selection of elements that are a good match in terms of size will ensure continuity when they are spliced together. Cutting some pieces exactly around the edge while including parts of the backgrounds of others exaggerates the mismatched effect, making for a more interesting collage, as well as playing down any fitting issues.

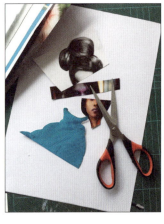

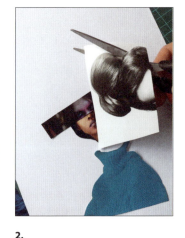

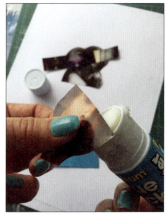

1.
Scour magazines for figures with interesting features. Collect hair, eyes, nose, mouth, chin, neck and torso. Roughly cut out each of the features to assemble your kit of parts.

2.
Carefully cut around the outlines of some of the features, such as the hair, but then bluntly cut others (perhaps the eyes or the mouth) into strips that include the background to the image. Contrast your cuts.

3.
Build your character feature by feature. Overlap some images with varying widths to create an interesting dynamic. Use a light application of glue when fixing features onto the page to allow the edges of the paper cut-outs to lift, curl and cast shadows.

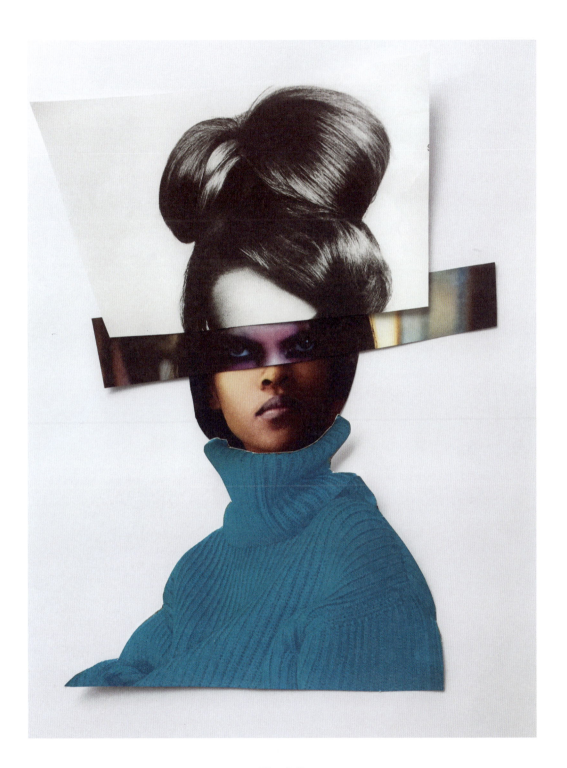

Mixed Up
(magazines, scissors, glue)

37. Mash-up

A persona can be created from an array of disparate colourful elements, and not just human features. Character can be conveyed through a judicious selection of components; each piece of the collage gives us a clue to the personality of the subject. Here, a limited, earthy colour palette suggests seriousness, even sadness – particularly with the carefully chosen facial features: a pouting mouth and a sideways glance. In combination with the impressive headgear and statement jewellery, this character has complexity. Perhaps her outward strength masks a sensitive interior.

Maybe you'll be inspired by someone real and pick elements that represent them, or you could invent someone entirely from your imagination.

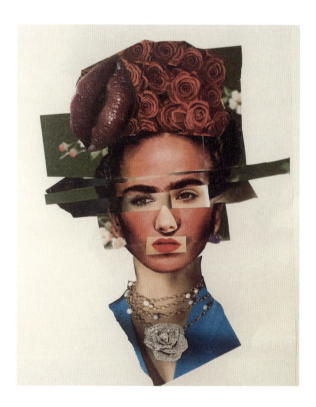

An Adventure of the Mind by Timuchin Dindjer
(magazines, scissors, ruler, glue)

A sharp contrast from the previous mash-up, where we see complex composition up built from many pieces: here, we have simplicity with one dramatic change. The secret is in the match. A black-and-white marble profile morphs into a human head, carved hair merging with real-life curls, combining beautifully. A careful fit is needed to make a convincing portrait, so resize the images until they match perfectly. The seamlessness of the collage means the mix of gender goes unnoticed.

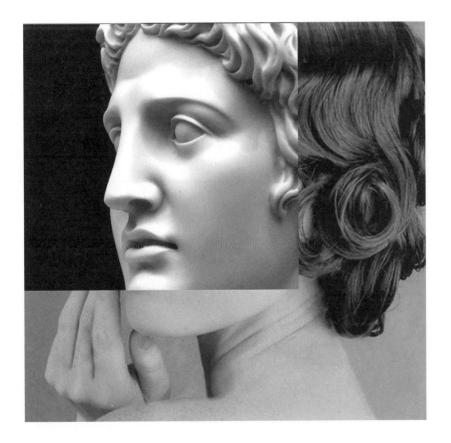

Statuesque
(magazines, scalpel, ruler, glue)

Persona 103

38. Graphic

Transparent sheets of coloured acetate or cellophane are an easy and effective way of adding colour to a black-and-white portrait. A few well-placed colours may alone be enough for a powerful collage, but you can take it a step further by also slicing and moving the image to achieve an interesting shape and dynamic. Here, a photocopy of the original image has been cut into fairly regular strips, which were then overlaid with primary colours, highlighting the eyes in blue and the lips in red while randomly placing the others. Leaving some strips free of colour makes a strong graphic composition.

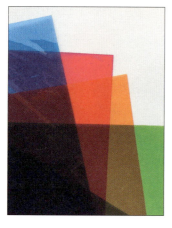 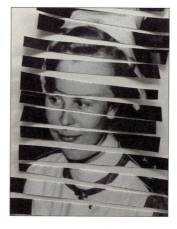 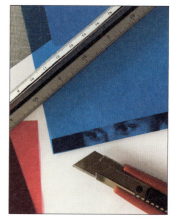

1.
Select sheets of coloured acetate or cellophane, then choose a strong black-and-white portrait with plenty of contrast.

2.
Using a scalpel and ruler, slice the portrait neatly into strips. Decide which sections of the image you wish to add colour to and those that you are leaving as monochrome.

3.
For those you are adding colour to, apply glue to the surface of the strip and cover with a coloured sheet. Using a scalpel and ruler, trim the coloured sheet in line with the image. Place all the strips on a neutral background to recreate the portrait. Glue them in place.

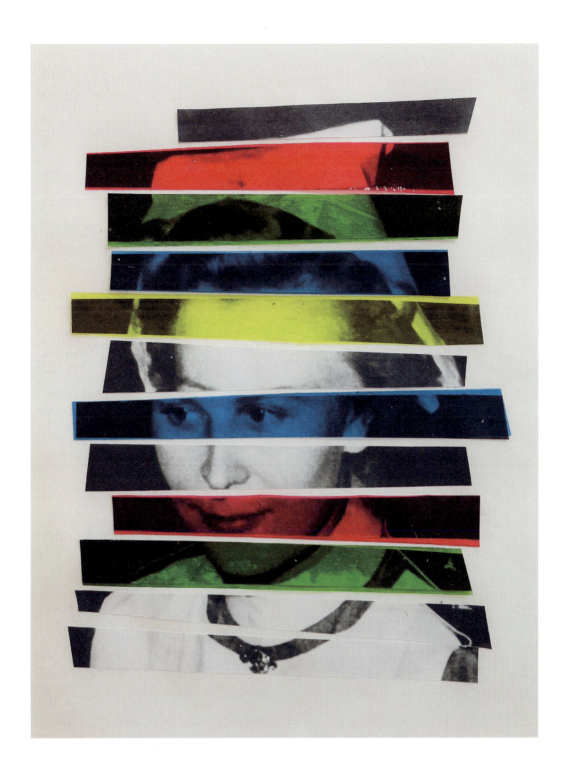

Three Pips
(photograph, photocopier coloured acetate or cellophane,
scalpel, ruler, glue)

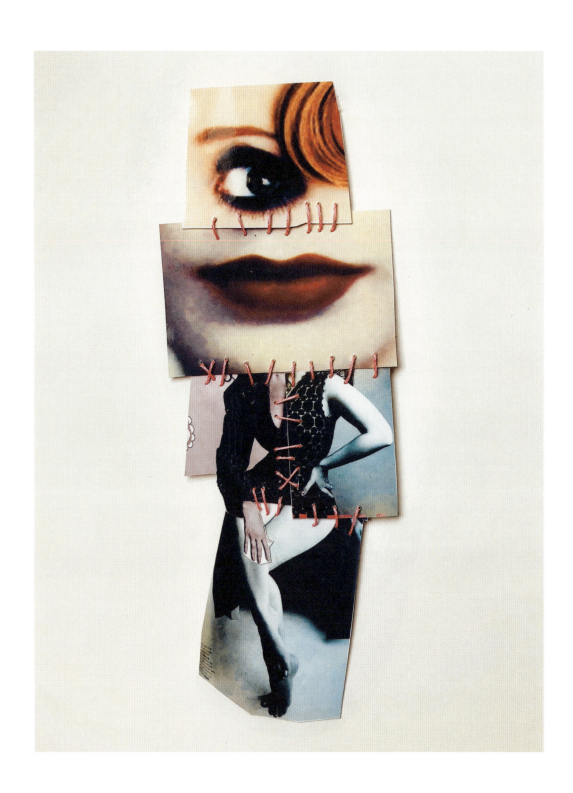

Stitched
(magazines, scissors, thread, needle,
masking tape, paper, glue)

39. Stitched

Create your own Frankenstein's monster by stitching body parts together. The effect is strengthened by missing out some of the parts. Here, the body is almost complete, but the single eye and mouth are enough to suggest a face. Similarly, play with proportion, scaling certain parts up or down. Think about what the size of an element says about its importance within the composition, and the meaning it suggests. Finish it with a needle and thread: loose stitching adds texture to the collage as well as being an effective way of joining the pieces together.

1.
Assemble a collection of body parts from magazines. Cut out each one roughly; there is no need to cut closely around the shape unless you would like to overlap some features.

2.
Rearrange the cut-outs until you hit upon the right composition. If necessary, trim the component pieces to fit. Once the features are assembled in order, secure them in position with pieces of masking tape.

3.
Using a large needle and colourful thread, stitch together the collage pieces with straight stitches and cross stitches. Waxed linen is a good choice of thread as it is strong and glides easily through paper. Knot any ends on the back of the collage. Mount your finished piece onto a neutral paper using glue.

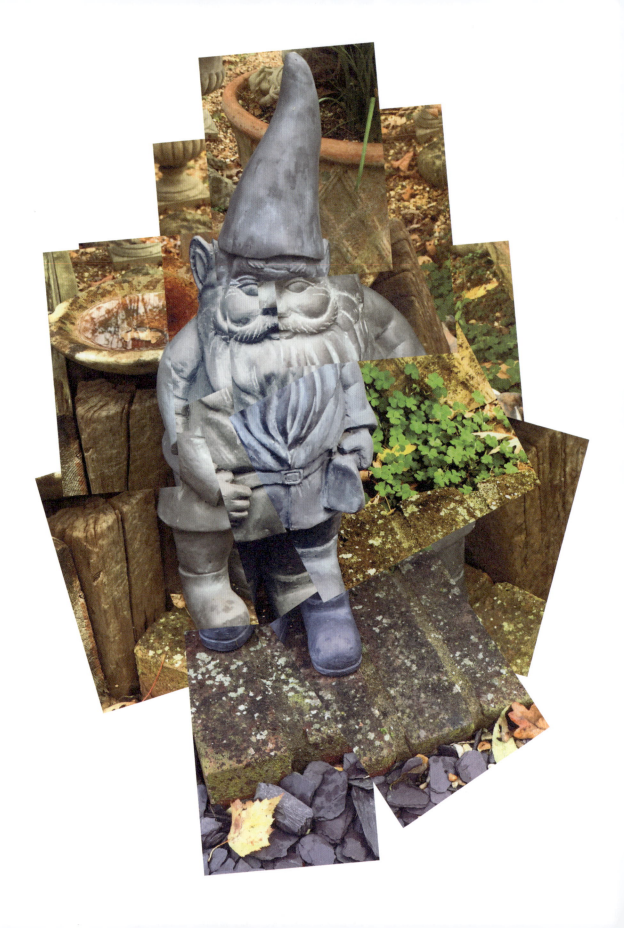

Joiners

During the 1980s, British artist David Hockney experimented with photographic collages using Polaroids and prints, which he called 'joiners'. Hockney's joiners are collages made up of multiple photographs taken from different viewpoints of the same subject, then layered together to form a single complete image, not at all dissimilar to the cubist artists of the early twentieth century who brought different views of the same subject together in one image. Eschewing the conventional device of linear perspective, the subject is broken down into many planes. Not only does this better represent the three-dimensional form of an object or scene, it can also allow you to play with the transient qualities of its appearance – how it changes according to the light, the season, the effects of ageing.

Creating a joiner is a tricky process, but leads to fantastic results. Ideally you want to align the individual photographs to form the composite image, but remember that the mismatching distortion and variations in colour are what will give the final piece its interesting patchwork quality.

Sean
(photographs, scissors, glue)

40. Building a picture

Scenes and scenarios make great subjects for a joiner, as the process elaborates the detail within – the more varied and detailed the scene, the more complex the joiner. When photographing your subject, look at it from all directions, move around it, vary the angles and your distance, zoom in and out. Capture as many shapes, textures and details as possible. Print out the shots ready to reassemble them.

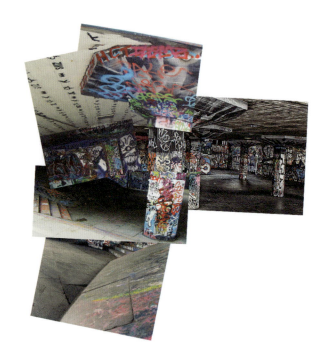

1.
Shoot an object or view from several different positions and angles. Look right and left, up and down and get close to capture details.

2.
Print or develop the photos and play with them like a puzzle, selecting interesting and informative shots. Piece the shots together, giving thought to the shape of the final piece.

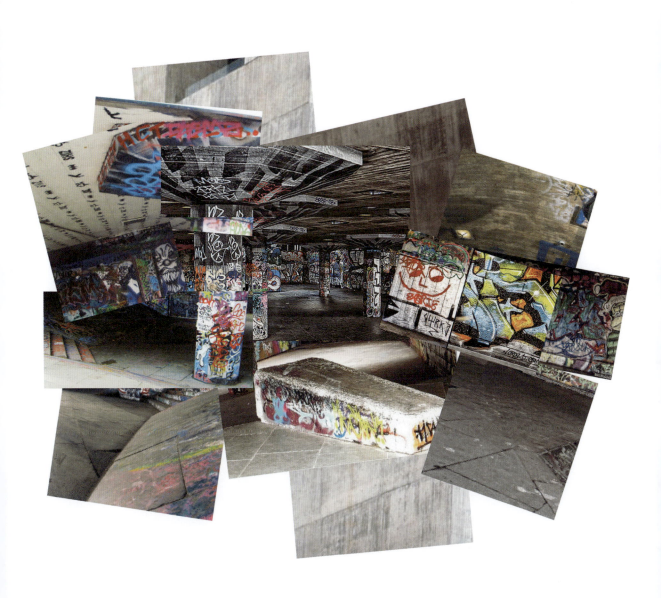

Skate Park
(photographs, scalpel, ruler, glue)

When considering a subject matter for a joiner, think about how you can deconstruct the scene or object into planes or sections and details to then later reconstruct it in an imaginative way. The collage of the chair combines many angles of the same subject within one image, giving a convincing sense of the chair's three-dimensionality, as does the gnome from page 108.

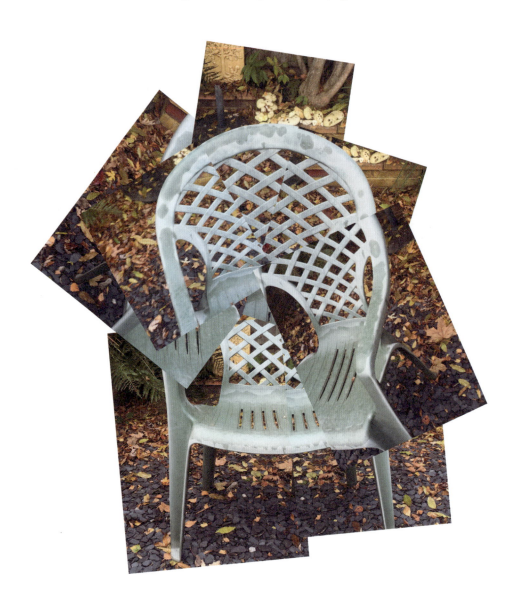

Chair
(photographs, scalpel, ruler, glue)

41. Deconstruct

Deconstructing and reconstructing an individual photo is another approach to making joiners. The slightly wonky overlaps and spaces between the cut-up pieces amplify the sense of a fractured reality, and here suggests the frenetic energy of a city at night. You can create variation in the colours of the pieces by taking photocopies of the original and altering the colour-strength and contrast settings on the photocopier. Select sections from each copy to rebuild the composition.

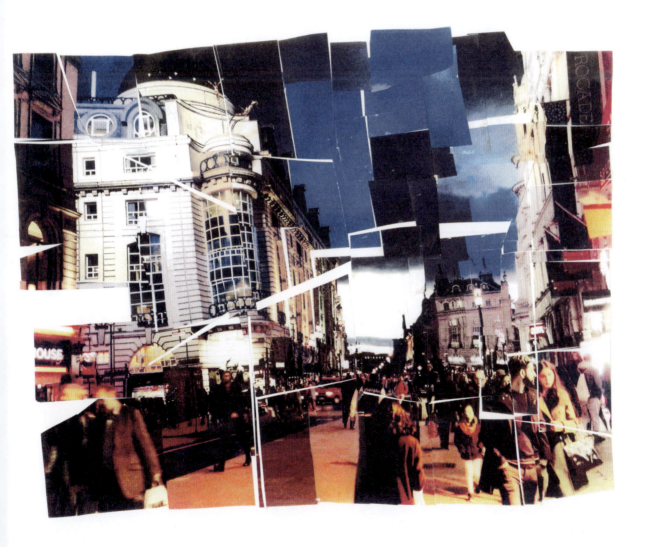

Big City **by Jaeyun Hong**
(photographs, scalpel, ruler, glue)

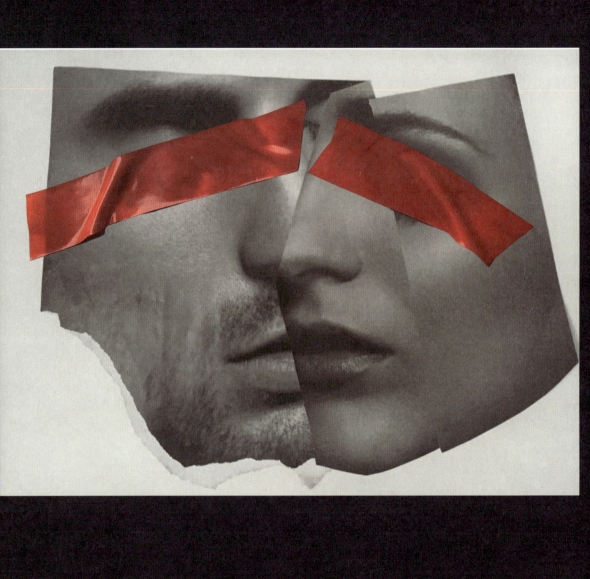

Mixology

Introducing materials other than paper into your collage – tape, tissue paper, pastels, paint – invites you to consider the innate qualities of these different media and how best to exploit them in your work. Every medium has a quality to offer: the rough and broken textures of oil pastels; the fluidity of paint that can be applied as a thin wash or built up using impasto, where strokes of thick layered paint build to capture expression and convey feeling; the delicate, ghostly tones of layered tissue paper and the provocative and tactile qualities of tape. Using mixed media adds another layer to a collage.

Try some mixology experiments by introducing one other material. Here, the black-and-white combined images are highlighted with strips of red tape placed strategically over the eyes. When working with tape, spontaneity is important: a wrinkled line has more integrity than one that's neatly and painstakingly positioned. The bumps and ripples in the tape enhance the passion and turmoil conveyed in this composition. Consider your additional media not only as a tool, but as an element with its own form to be explored.

Bliss by Timuchin Dindjer
(magazines, tape, scissors, glue)

42. Oil pastel

Be inspired by Mark Rothko and his fantastic colour combinations by mixing up your collages with colourful oil pastels. Rothko used colour as a means of expression, and with a desire to provoke emotion. His simple blocks of colour with blurry edges give the impression of floating shapes within his giant canvases. He limited his colour and shape choices to maximise their impact – try to convey this within your collage. Start by creating your own abstract base. Oil pastels blend well and give texture to a plain background. Take inspiration from the base when adding your collage elements. In this example, the hands grip tightly to the pink pastel square and the blue rectangle curiously becomes a substitute for hair.

1.
Using oil pastels, add bold blocks of colour to a black paper base, choosing strong, vibrant colours that contrast or complement each other.

2.
Work quickly to create soft edges and a grainy texture. Blend and blur the vivid colours into the background. Scratch into the surface with the edge of a piece of card or ruler depending on how delicate or dramatic you wish the appearance to be.

3.
Cut out and assemble a simple composition, like a face, made from different sources and glue it into position. Here, the interaction of the hands with the pink block integrate the two different kinds of imagery so that there is a unity to the piece.

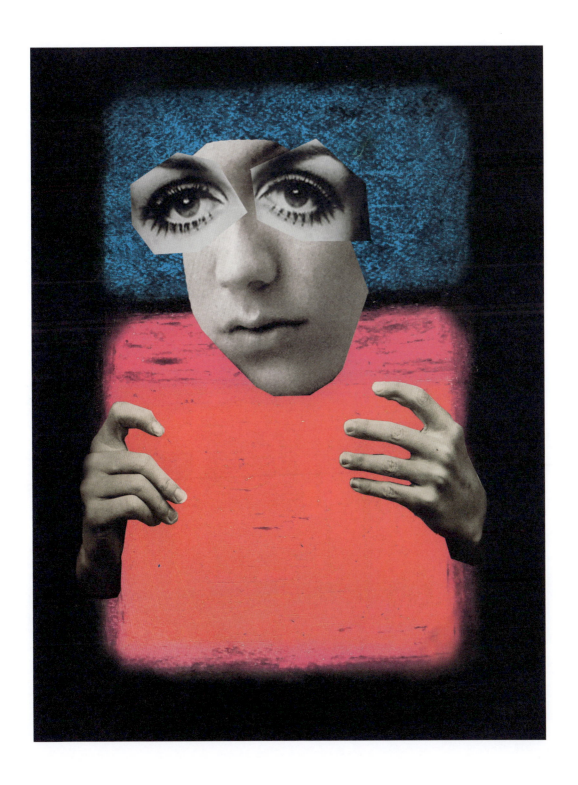

Pink and Blue
(magazines, oil pastels, scissors, glue)

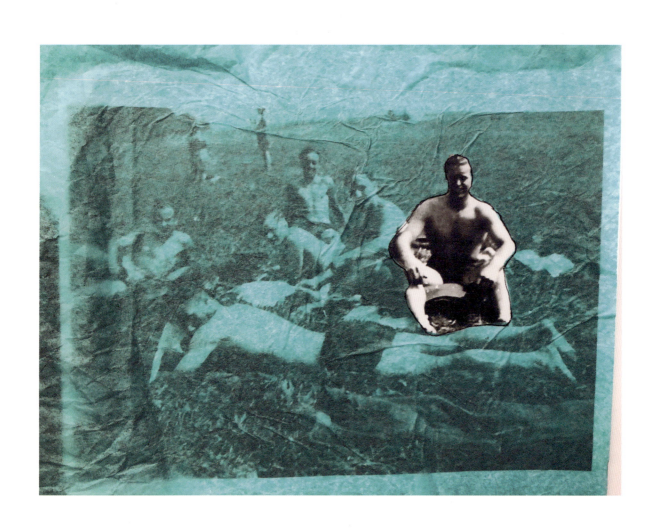

Bathers
(photograph, tissue paper, pen,
scalpel, scissors, glue)

118 Mixology

43. Tissue paper

Create a collage using tissue paper as a mask and then reveal a part of the image underneath. Tissue paper laid over a strong, high-contrast image creates a knocked-back effect, partially obscuring the base image. Then you can single out a particular person or feature by carefully cutting the tissue around them. It's tricky to work with because it's so delicate and once glued it cannot be repositioned; as a medium it will always yield unique results. Any ripples and creases in the glued paper add an interesting textured quality to the collage, creating light and shade. Building on from this, you could try using multiple pieces of tissue overlapping in one collage.

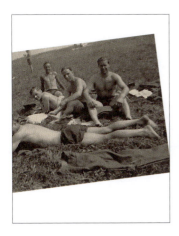

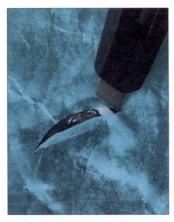

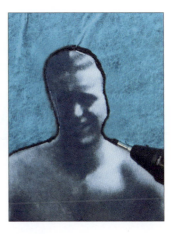

1.
Select a strong contrasting photograph or image, preferably a scene rather than a single subject.

2.
Lay a sheet of coloured tissue paper over the image and cut away areas of interest that you wish to make the main focal point of your collage. For accuracy, use a scalpel or craft knife rather than scissors. Coat the tissue paper lightly with spray glue or gently apply glue from a stick to the base photograph and apply light pressure.

3.
Depending on your image and how much contrast it has, you may want to use a fine black pen to outline your cutaway to intensify the area in comparison to the rest.

44. Paint

Features painted over newspaper and tissue paper makes this collage a real mixed-media fest! First, glue and position your base papers, then start to work on top. Carefully position any visible text – here it integrates with the features of the face, creating shadow between the eyes and the bridge of the nose. Vibrant colours and charcoal lines help define the figure's icy stare. Use paint to blend images together and unify a complete canvas.

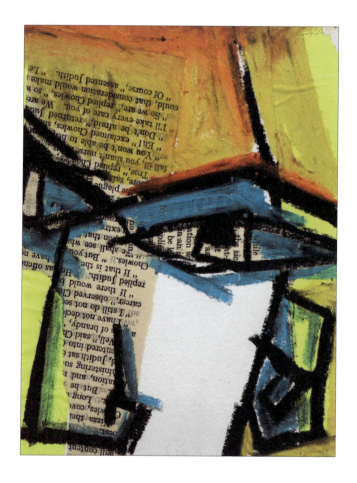

Stare **by Cath Speight**
(magazines, newspapers, paint,
paintbrush, scissors, glue)

Painted photocopies make an intriguing collage base. This base layer can be a single photocopy of your image or a montage of a few images glued together. Using paint, block out the background to leave a particular detail visible. Make it stand out even more by adding vibrant, contrasting colours. A paint-loaded dry brush creates even more interest in the piece as the brushstrokes remain visible. The photocopier paper will start to curl and bend as it dries. Once dry, the contours will catch the light and add texture.

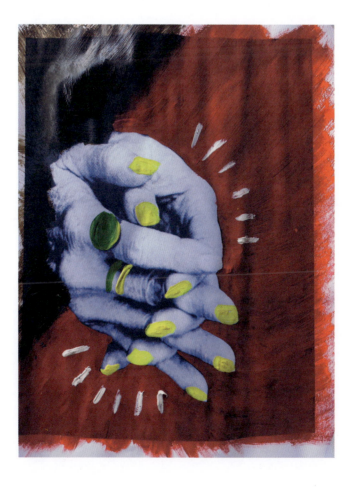

Prayers
(magazine, photocopier, paint, paintbrush, scissors, glue)

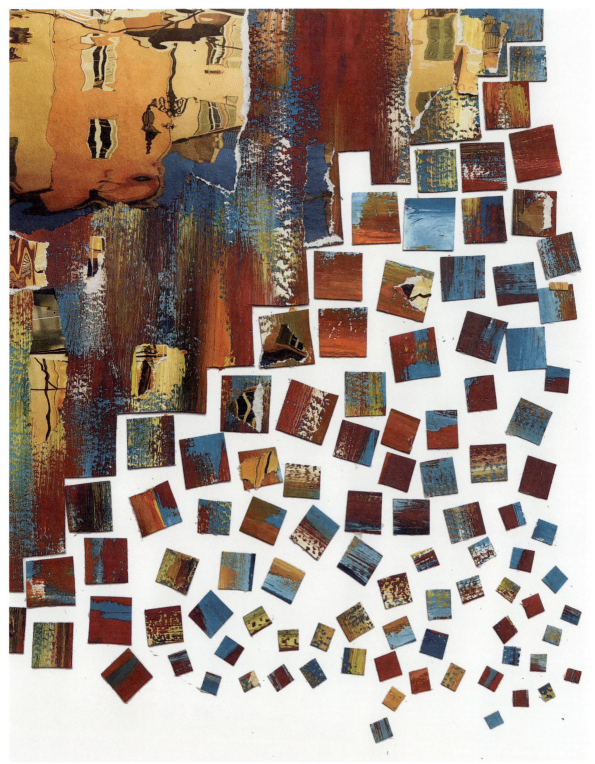

Falling
(watercolour paper, magazines, paint,
paintbrush, scalpel, glue)

45. Disintegrate

Create two collages in one. Make an initial abstract collage of torn paper images and abstract brushstrokes, then allow it to dry. Now cut it up and watch it tumble into a second arrangement full of movement.

 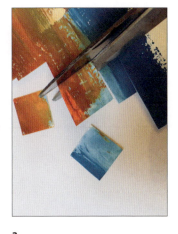

1.
Take a sheet of watercolour paper and work an abstract composition into it with a combination of collage and paint. Let the colours of the collage influence your paint selection. Dragging a loaded brush across the image creates a dramatic textured effect.

2.
Allow your collage to dry, then, using a scalpel or craft knife, cut the collage diagonally across in steps from the top right down to the bottom left, or vice versa, depending on the composition of your collage.

3.
Leave the top section intact, but take the bottom section and cut it into squares using scissors. As you work downwards, reduce the size of the squares. Once all the squares are cut, piece them back together with spaces in between (as seen opposite).

Mixology 123

Repeat

When an object is repeated multiple times within a single image, it takes on a greater significance. A humble object can be transformed through repetition, just as the Campbell's soup can was when American artist Andy Warhol depicted it 32 times on almost identical canvases. When layered, multiple images create texture and pattern.

Set yourself the challenge of collecting as many images of one subject as possible, then combine them in collage. Photographs of my father's old cars, stacked in a teetering pile, work perfectly in a repeat collage. Body parts, meanwhile, are interesting and easy to come by in fashion magazines. Imagery for these lively combinations is fun to collect, but it can become obsessive.

When composing a repeat collage, consider the placement of each element within the overall image, and the impact it has on the story being told.

Pile Up
(photographs, coloured paper, scissors, glue)

46. Movement

Images can convey an idea powerfully and when your bring repetition into the equation, the impact increases exponentially. This image is all about movement, so a series of dancing bodies are overlaid against an abstract texture, building a sense of rhythm. Action is key in this collage, with poses selected to reinforce the dynamic feeling. A restricted colour palette strengthens the result. This collage started with the split main figure dressed in red leaning backwards with exaggerated limbs projecting outwards, and the execution of the rest of the collage followed from this one figure.

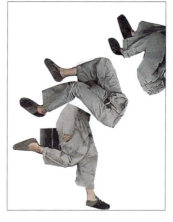

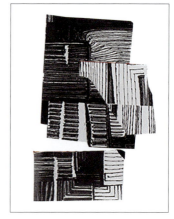

1.
Choose a strong subject with a dynamic pose to start with. Split this figure and arrange the pieces on the page in a way that's appropriate for the feeling or theme the figure suggests. Here, a diagonal arrangement suits the energy of the piece. This will be the holding shape for the rest of the piece.

2.
Collect figures, objects and so on that fit with the theme. Carefully cut out each piece and arrange them on the paper, adding to the collage. Build outwards from your holding figure. Don't fill all the paper as white space helps to focus the eye and strengthens the overall shape.

3.
Add a texture to unite the elements and create a background shape – this might be another collaged element, or hand-drawn, but be careful not to overpower the other elements of the collage, which are the main focus. Keep the colour palette simple, unless a busy palette works for the idea you're conveying.

126 Repeat

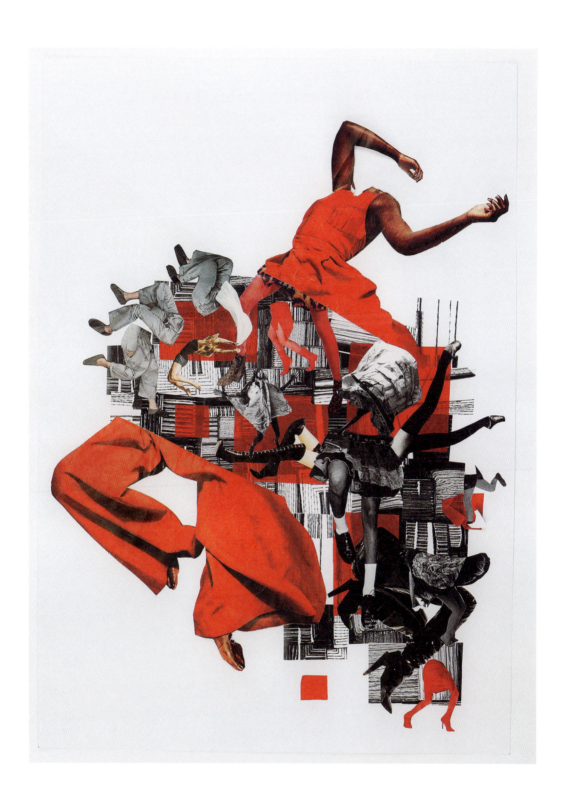

Jump **by Lucy Mills**
(magazines, photocopier, scissors, glue)

47. Multiply

Swapping up body parts is fun. Try replacing one body part with a different one: hair with arms, feet with hands and so on. Add to the operation with graph paper for a medical-style background, keeping it clean and clinical.

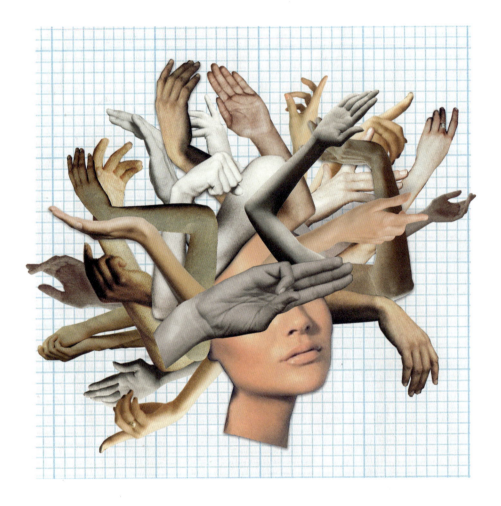

She Was All Fingers and Thumbs
(magazines, graph paper, scissors, glue)

Play around with different body parts, putting them together in different and surreal arrangements and containing them within a shape – here we have multiple eyes framed by glossy lips, but eyelids, cupped hands, ears and so on will all work well.

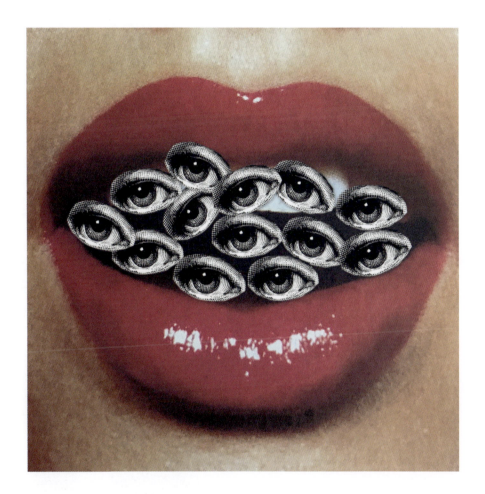

Say What You See
(magazines, photocopier, scissors, glue)

Repeat 129

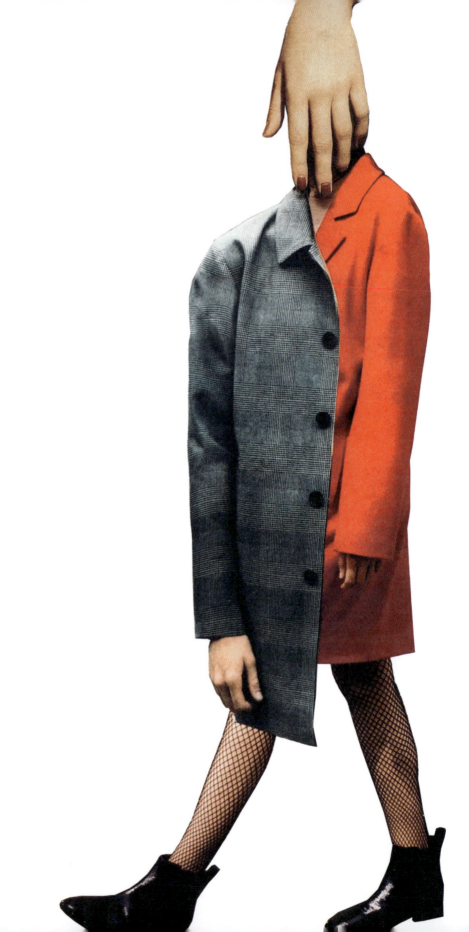

Fashion

Fashion and lifestyle magazines are a bountiful resource when creating collages. Before recycling them, search the pages for distinctive images to repurpose. Fashion magazines often feature striking poses and expressions that create strong compositions, along with fantastic colours and textures.

Deconstruct and then reconstruct models and outfits, figures and garments. Play around with clashing and complementary colours, textures, shapes and contours. Manipulate the human form by creating outlines from silhouetted figures, then fill the spaces with interchangeable looks. White space can add drama and draw attention to the shapes created, so make space for your subject and consider how it looks on the page. Anchor your image by extending it off the top or bottom of the page, or overlap profiles to create patterns and textures.

```
What to Wear?
(magazines, scissors, glue)
```

48. Frame it

The photography you find in fashion magazines is fantastic for collage, offering exquisite shapes and close-ups of textures. There are so many incredible body shapes and poses to look out for. Creating a frame from a silhouette gives you the chance to make a strange, unsettling and beautiful composition. You can make the effect as subtle or shouty as you like. Experiment and mix colours and fabrics, or stick to skin tones and textures.

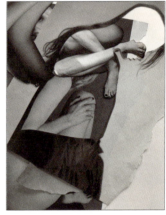

1.
Search fashion and lifestyle magazines for an image of a figure with plenty of definition and a striking silhouette. Using a scalpel, cut away the inner part of the body to leave a striking, clear silhouette.

2.
The negative space within the silhouette is now the frame in which other images will be placed.

3.
Select several different images to use as fillers. Experiment to see which work best. Try filling the silhouette with images of other body parts – hands, arms, legs – blending folds and twists of skin to create an abstract or surreal composition.

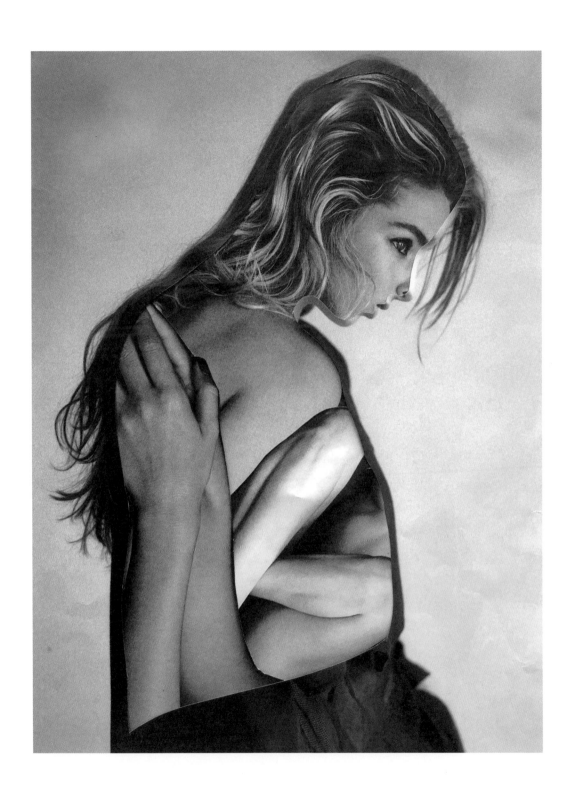

Lipsync
(magazines, scalpel, glue)

Photocopy your frame multiple times and cut out and remove the centres. See how many different looks you can come up with from the same frame. Rich folds and swathes of fabric give the illusion of depth. Or think like the cubists and create multifaceted faces with angled planes. Front-facing features may sit comfortably inside a sultry profile and vice versa. Match the mouth and nose and you can create a mesmerising distortion.

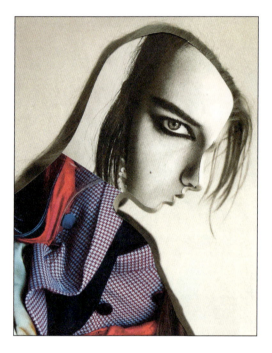

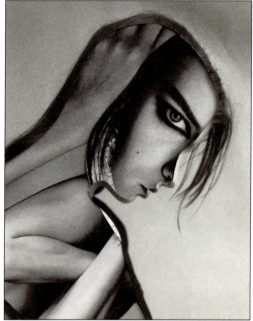

Clothes Horse
(magazines, photocopier, scissors, glue)

Picasso-esque
(magaziner, photocopies, scissors, glue)

By enlarging an image out of all proportion compared to the frame, it becomes a shape devoid of its original meaning. In the image on the left, it becomes hard to see the geisha's heavily painted lips as anything other than a woolly hat on the bowed head of the figure in profile, while on the right the slick of lipstick matches up perfectly with the silhouette so they share the blood-red pout.

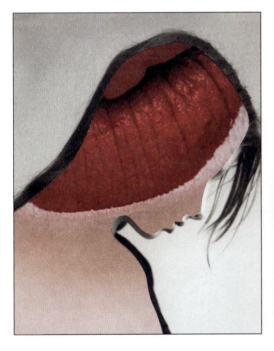 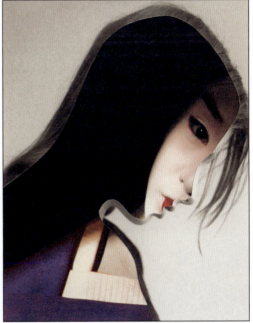

Beanie
(magazines, photocopier, scissors, glue)

Geisha
(magazines, photocopier, scissors, glue)

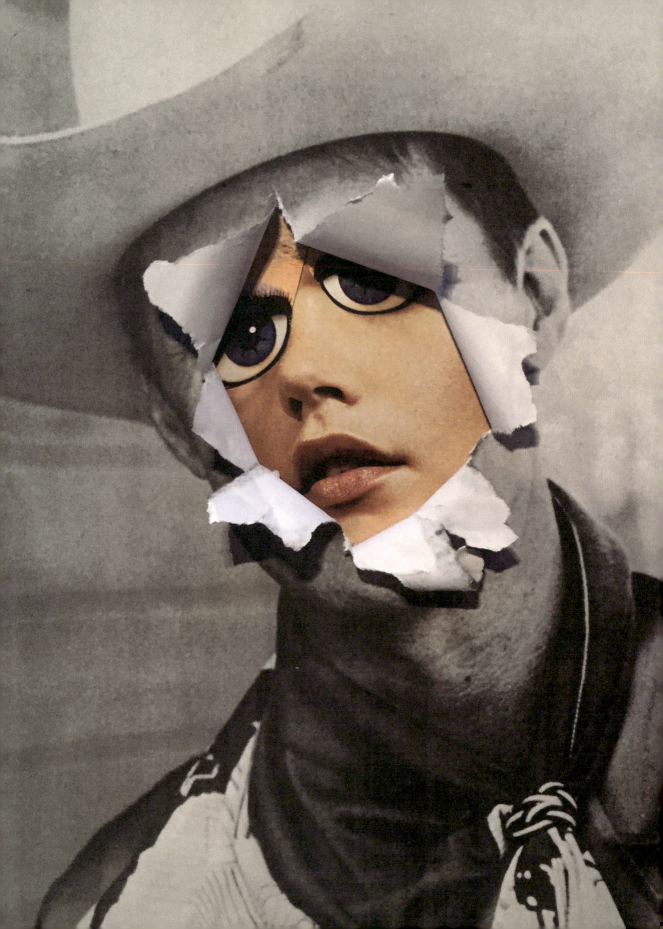

Inside out

Cleverly tearing, slicing and folding the upper layer of a double-layered image can expose an inner reality, a hidden underworld or a jack-in-the-box-like surprise. By puncturing a hole in a collage – either creating a peephole inwards or an explosion outwards – you can reveal the truth that lies beneath the surface or create a surprising juxtaposition of absurd elements.

Carefully tearing an image at its central point, then curling back the paper, allows the image beneath to burst through. This simple technique is an effective way to combine two portraits as the torn outer image frames the inner visual and gives the impression of a person within a person. With these 'inside-out' techniques, there are endless possibilities to exploit the three-dimensionality of collage and peer through one image to an intriguing world beyond.

Cowgirl
(magazines, scissors, glue)

49. Reveal

Mundane grey apartment blocks are peeled back to reveal a contrasting colourful paradise idyll within. This three-dimensional collage is made using two images, one overlapping the other with slits carefully cut in the top image and folded back, rather like paper shutters that are opened to unveil another scene underneath. The flaps are left protruding to give a three-dimensional effect.

 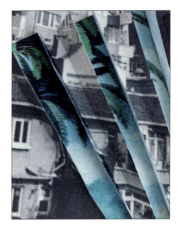

1.
Select two contrasting images and decide which will be the upper image. Lay tracing paper over this image and secure it with masking tape. Using a pencil and ruler, draw geometric shapes over the image. Cut down the centre and across the top and bottom of each shape.

2.
Remove the tracing paper from the image to reveal a cut opening on each of the geometric shapes. Fold back both sides of the cut openings for each shape. Using your fingers, make sharp creases along each fold.

3.
Lay the upper image with the folded-back openings over the contrasting base image (see opposite) and glue them in place.

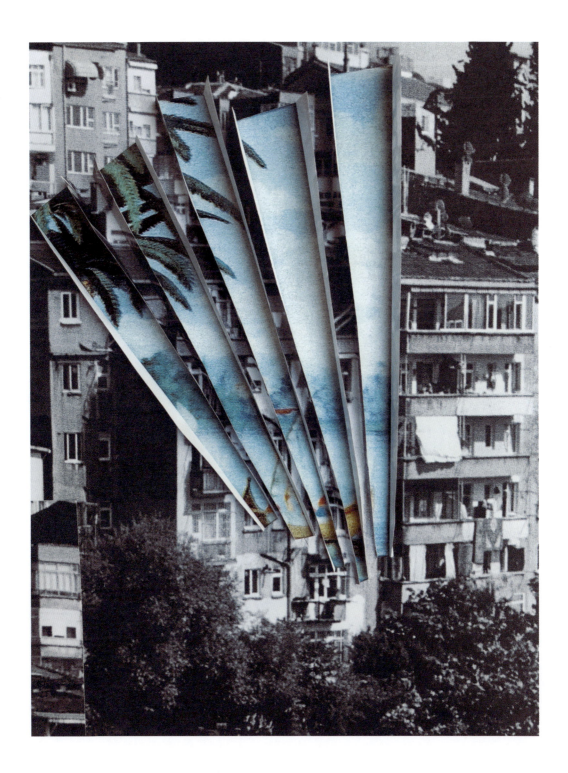

Paradise
(magazines, tracing paper, masking tape,
pencil, scalpel, ruler, glue)

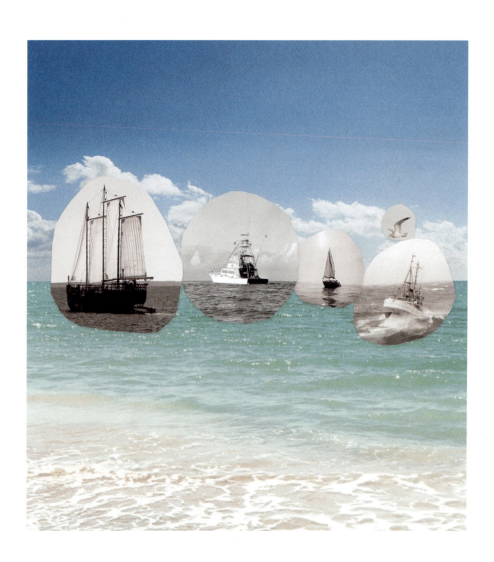

Horizon

140 Inside out (magazines, photographs, scissors, glue)

50. Peepholes

This project plays with the idea of looking beyond one image through to another. In this composition, the horizon of the colour seascape becomes the anchor point for the black-and-white images, which appear like a series of peepholes providing a glimpse into the past. A collection of black-and-white ships appear on the horizon, and a seagull hovers in the sky.

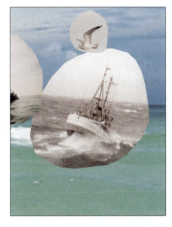

1.
Select a colour image for the background with plenty of usable space that will work as a blank canvas for your focal points. If you can't find the perfect landscape in one image, then create one yourself by collaging different images together.

2.
Gather a selection of different images on the same theme. Here, I specifically chose only boats sitting on the horizon, to make the distortion stranger yet more convincing. Using black-and-white images provides contrast against a colour background, as well as a sense of looking into another time.

3.
Cut the images into loose circular shapes. Position these cut-outs over the background, rearranging them until you are happy with the composition. Position them carefully, considering perspective and alignment with other elements in the background, for instance the horizon here Glue everything in place.

Inside out 141

Acknowledgements

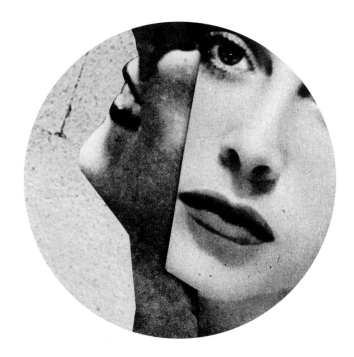

Image credits:
Introduction, page 7 © Succession Picasso/DACs, London 2018; 8 above © Estate of the Artist, c/o Lefevre Fine Art Ltd; 8 below © DACS 2018. All images © Tate, London 2019.

Artworks by Bev Speight unless otherwise stated. Photography by Bev Speight.
Text, illustrations and photography copyright © Bev Speight 2019

Acknowledgements:
A big thanks to these lovely people for making this book possible – in no particular order...

My agent, Chelsey Fox, for her support and guidance; my fabulous family for their love and encouragement; the very talented contributing artists – Baha Khodadadi, Elizabeth Fadairo, Lucy Mills, Timuchin Dindjer, Jaeyun Hong and Cath Speight; the wonderfully creative team at Ilex – Helen Rochester, Zara Anvari and Rachel Silverlight; and my loving parents Brenda and Tony Speight who are always in my heart.

About the author

I am passionate about art. An award-winning graphic designer, illustrator and art educator, I started out at London design agency Michael Peters, then worked for the BBC and HarperCollins Publishers before co-founding the design partnership XAB Design. Now an independent creative, my projects include corporate identity, branding and promotional design, book illustration and photographic art direction.

I balance time between my creative design practice, university and books.

For the last eight years I've been working with students at Middlesex University, London, where I lead the Visual Arts and 3D Design BA foundation year programmes and the intensive foundation programme. The projects I design for these programmes emphasise research, collecting, experimenting and being inspired so that creativity flows – and art becomes fun.

I also work with young students at the National Art and Design Saturday Club at Middlesex University, which I structure in a similar way to the foundation courses, offering a variety of experimental projects to get them excited about art and design.

Feedback from the programmes, teachers and parents, asking if there was a similar course opportunity for artists wishing to develop their love of art, inspired me to write my books. I love guiding others to explore the world as artists, and to create work that they may never have expected from themselves.

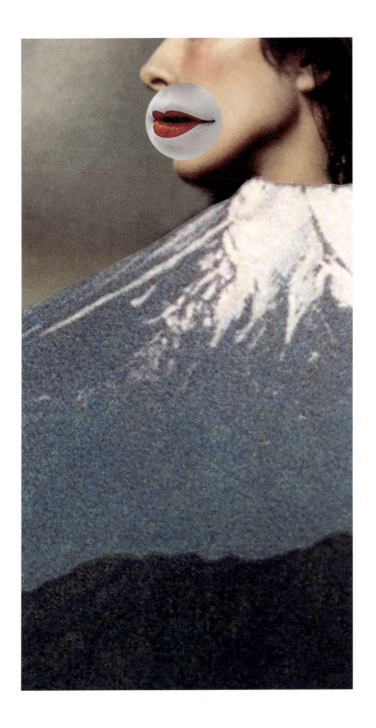

Fuji
(magazines, scissors, glue)